IMAGES
of America

WARREN

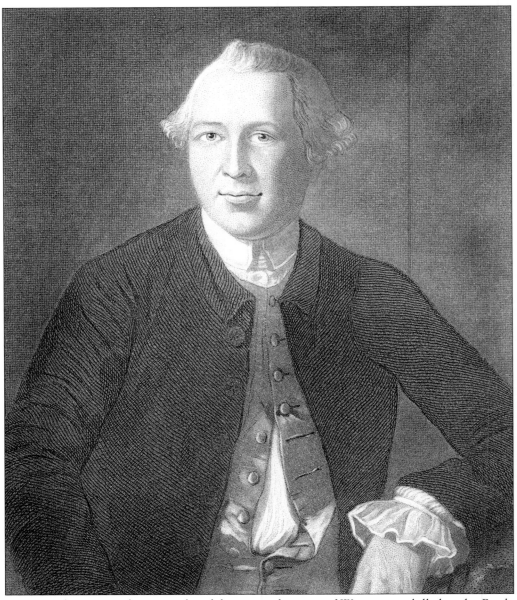

Gen. Joseph Warren, the namesake of the city and county of Warren, was killed at the Battle of Bunker Hill during the American Revolution.

IMAGES
of America

WARREN

Jodi L. Brandon for the
Warren County Historical Society

ARCADIA

First published 2002
Reprinted 2002, 2003

Published by Arcadia Publishing,
an imprint of Tempus Publishing Inc.
Portsmouth NH, Charleston SC, Chicago,
San Francisco

Printed in Great Britain

Library of Congress Catalog Card Number: 2002100845

For all general information, contact Arcadia Publishing:
Telephone 843-853-2070
Fax 843-853-0044
E-mail sales@arcadiapublishing.com
For customer service and orders:
Toll-free 1-888-313-2665

Visit us on the Internet at www.arcadiapublishing.com

*With love and thanks I dedicate this book
to my Bop, whose memory brings me home to
Warren more than anything else does.*

CONTENTS

ACKNOWLEDGMENTS

My thanks go to the staff and volunteers at the Warren County Historical Society—particularly Rhonda J. Hoover, Shelly Neel, and Karen Ahlgren—for their enthusiastic support and expertise.

Special thanks also go to my husband, Dave, for his support of me and belief in this project; to my parents for teaching me what "home" means (and for countless trips back to Warren after we moved); and to my Aunt Eileen for a note of encouragement written so long ago she probably doesn't even remember it.

INTRODUCTION

The land for the city of Warren was deeded to the commonwealth of Pennsylvania in 1785 by the Seneca Indians at the Treaty of Fort Stanwix. So began the history of the community, named after Gen. Joseph Warren, a hero of the American Revolution. In 1795, Gen. William Irvine and Andrew Ellicott, Pennsylvania's state commissioners, laid out the area where the Allegheny River meets the Conewango Creek for a settlement. There would be 6 streets running east to west and 10 running north to south, all but three of which would be 60 feet wide. The exceptions were 100-foot-wide Market, Water (now Pennsylvania Avenue), and High (now Fourth) Streets.

Rich in natural lumbering resources, the new community of Warren thrived. In 1832, with a population of 385, Warren was incorporated as a borough. Also in 1832, the Lumbermen's Bank was established, and so was the banking industry in Warren. The oil boom, the emergence of railroads, and the establishment of businesses and manufacturing throughout Warren contributed to its growth and prosperity throughout the 19th century.

As Warren prospered financially, so did the sense of community among its people. This became more and more apparent throughout the first half of the 20th century as schools, churches, social clubs, hospitals, community services, and welfare programs to assist the less fortunate were established. Better (and free) education, care for the poor, and medical care were among the many issues the community faced together.

An 1895 advertisement for Warren's Union School described the sense of community flawlessly: "[Warren's] charming environment of river and mountain scenery, her culture and moral atmosphere, her spirit of progress and intellectual improvement, her well-stocked library, her liberal and thorough school advantages are but a few of her many attractions."

Space constraints prevent including every detail of the history that these images represent. There was no way to include every significant person, group, event, and place. My hope is that what is included triggers many happy memories for all and that readers enjoy the book as much as I have enjoyed creating it.

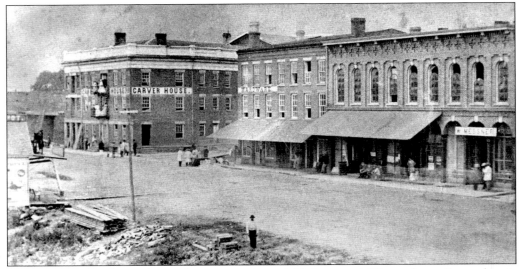

The photograph above shows the intersection of Hickory and Water (now Pennsylvania Avenue) Streets in 1868. The Carver House is prominent in the background; in the foreground are materials and evidence of new buildings under construction. Below is the Warren Armory.

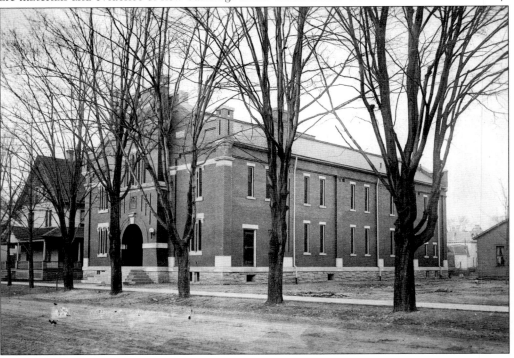

One
BUSINESS AND INDUSTRY

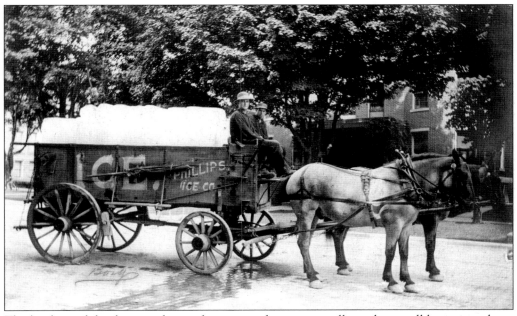

The lumber, oil, banking, and manufacturing industries, as well as other small businesses, have called Warren home over the years. Some businesses prospered. Others were forced to close their doors long ago, and still others struggled but remained in business. Success stories, such as John Blair's mail-order raincoat business, which evolved into today's multimillion-dollar Blair Corporation, are inspirational. The losses became lessons for future businesses. Businesses often changed hands, such as the Phillips Ice Company (a truck of which is pictured here), purchased by Wen Phillips in 1890. The Lumbermen's Bank—forced to close after the Panic of 1837— paved the way for the Warren National Bank, the Warren Savings Bank, and the First National Bank, among others. This chapter encompasses more than just facilities; it includes photographs of employees at work and at play, as well as the products that carved out a place for these businesses in our history.

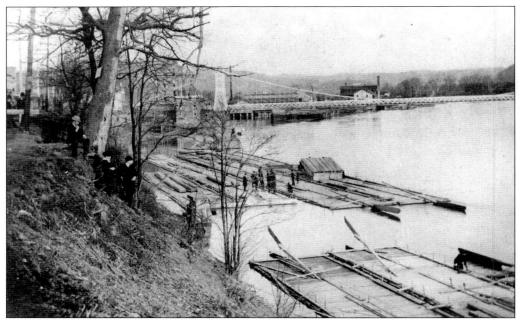

Because Warren is located in the heart of the Allegheny National Forest, lumbering was one of its first industries. Lumber was sold to larger cities, such as Pittsburgh, Cincinnati, and New Orleans. Lumberers built rafts, rafted down the Allegheny River to Pittsburgh (where they sold the lumber), and walked home—that is, until there were railroads to ride. This *c.* 1888 photograph gives a good indication of the size of the rafts.

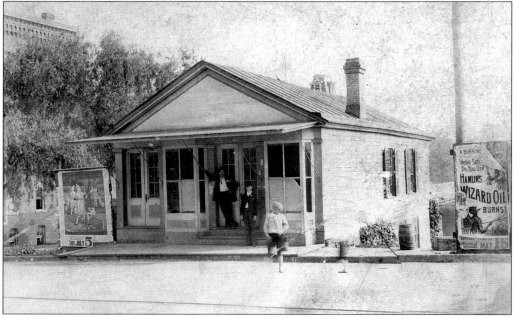

In addition to being a champion of the Presbyterian Church in Warren, Archibald Tanner is best known for being Warren's first merchant. He came to Warren in 1816 with very little and opened this small store near Jackson's Tavern.

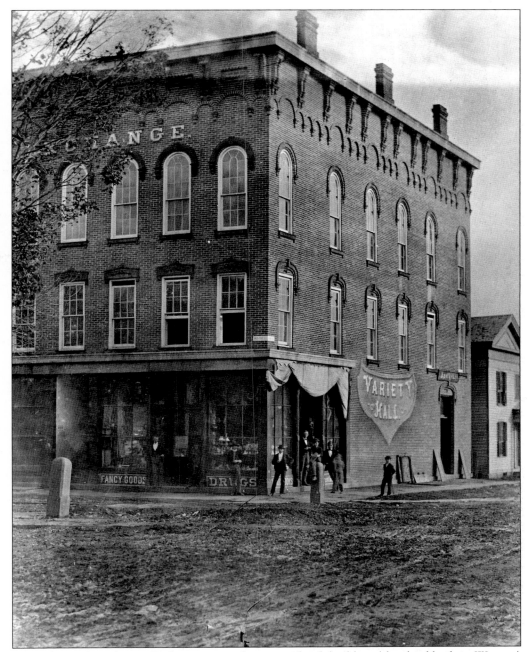

Erected in 1854, Johnson Exchange was a three-story brick building (the third built in Warren) that served several purposes. Housed on the first two floors were businesses (among them, over the years, various drugstores, the First National Bank, and the Piso Company). The third floor was for lodging and for Johnson Exchange, an amusement hall with the "reputation of being the best equipped amusement hall in the oil region." When the Philadelphia & Erie Railroad was completed in 1861, a magnificent ball was held here.

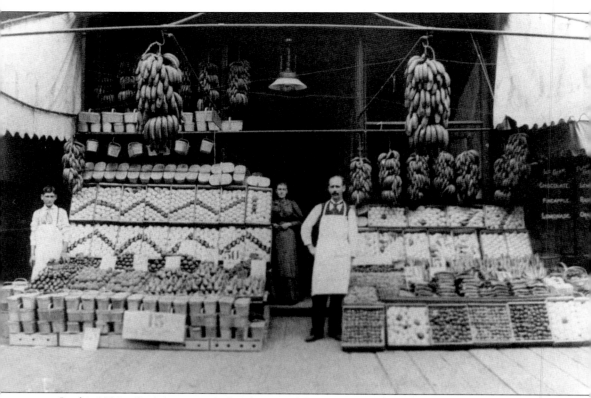

In the 1890s, Geracimos was a family-owned fruit, candy, and dry confections store with a soda fountain. Proprietor George Geracimos, in the apron, stands in front of the building at the western end of the Warren National Bank's site on Second Street. The building was torn down in the early 1900s.

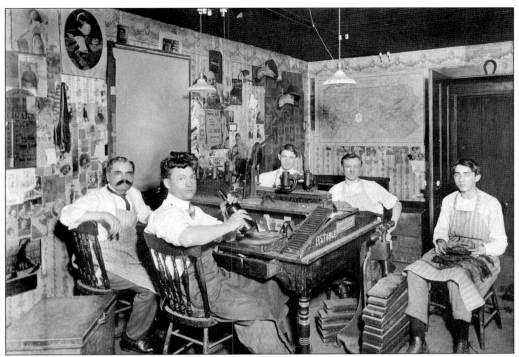

Cigar manufacturing was an important industry in Warren beginning in the 1880s. One-man operations, called buckeyes, operated in addition to companies employing several workers, such as the John O. Lunn Cigar Factory, whose employees are pictured here. Others included Warren Cigar Works, Maybank & Sailor, and the Steber Company.

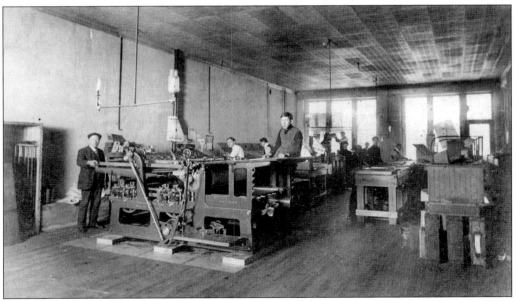

This photograph shows operations of Warren's newspaper, the *Warren Evening Times*, c. 1906. Silas E. Walker is on the left; William A. Walker is on the right.

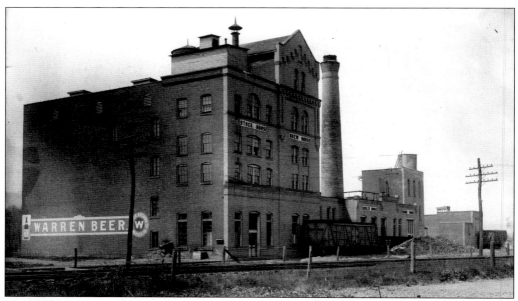

The Warren Brewing Company was incorporated on September 15, 1905. The company's offices were located on Pennsylvania Avenue West, but the brewery itself operated on Main Avenue on Warren's south side (at the Pennsylvania Railroad tracks) under the management of brewmaster Joseph Huber. The brewery was demolished in the 1940s, but the company had ceased operations in 1918 due to Prohibition.

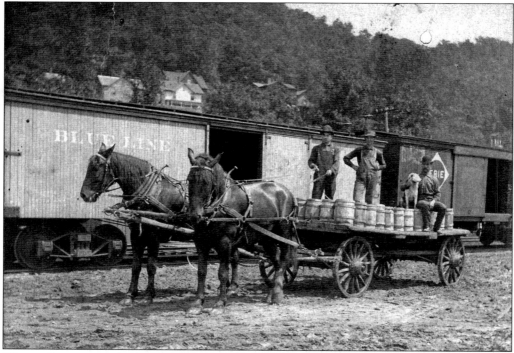

Warren Brewery employees are shown with a load of beer to be shipped on the Erie Railroad's Blue Line boxcar.

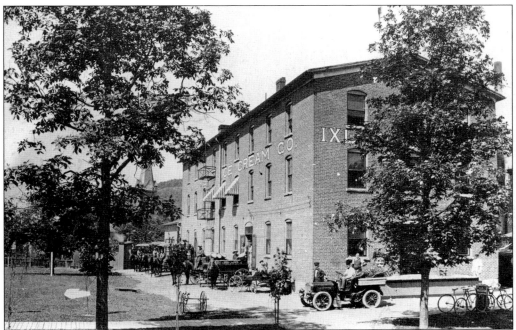

Edward Walker opened a restaurant in 1895 as a way to introduce his ice cream to Warren residents. Walker later opened the Walker Creamery, an ice-cream plant, which became the victim of a fire in early 1904, less than a year after this photograph (above) was taken. A delay in the fire company's arrival made it impossible to save the plant, but a new one was soon built. The new plant was considered a model for other plants that were being built at the time, with the most up-to-date sanitary features available. In addition to selling ice cream in a store and, later, shipping its product via railroad, ice-cream sales wagons (below) provided treats to children such as this one.

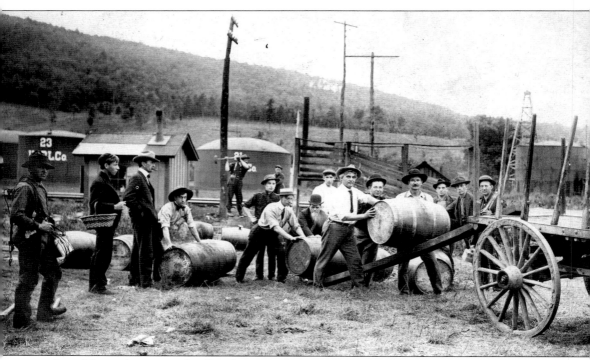

An oil boom known as the Grasshopper oil excitement caused quite a stir in Warren for two months in 1905. Oil was found in the Grasshopper oil field in Warren's east side flats. Resident John Larson had drilled a water well on his property. His son Edgar found oil when flushing the system one August afternoon. A newspaper account of the events remarked that "the sound of swinging mauls driving pipes into the ground echoed loud."

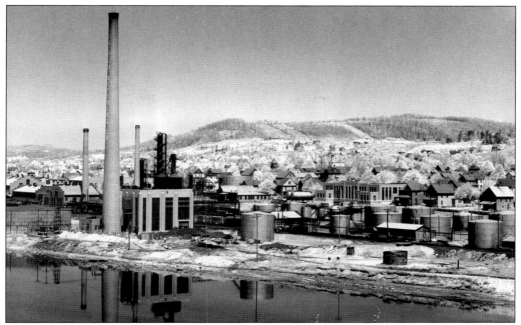

The United Refining Company started operations in 1902 as one of several oil refineries in the Warren area. By the early 1950s, United had grown and expanded its business. Its core products, lubricating oils, were sold nationally and internationally. During World War II, the U.S. armed forces used the majority of the company's products. The mid-1950s brought a period of expansion and modernization to United.

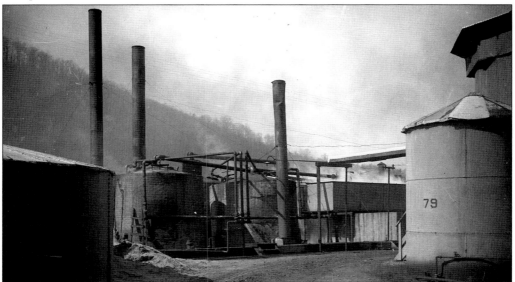

The Cornplanter Refining Company, which was situated on the flats, is just one of many examples of companies that defined Warren's oil-refining industry. At its peak, this refinery was one of Warren's biggest and most important institutions, processing upwards of 300,000 barrels of crude petroleum annually. Oil refining began as one of Warren's most vital (and profitable) industries and remains an active presence.

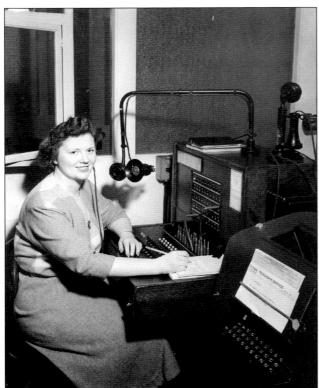

The Sylvania Electrics Products' parts division began production in Warren in 1943 after years in Emporium. A sophisticated telephone system was necessary to manage information from other Sylvania divisions as well as the parts division's hundreds of outside customers. One of the system's operators is pictured with telegraph equipment, shown on the right.

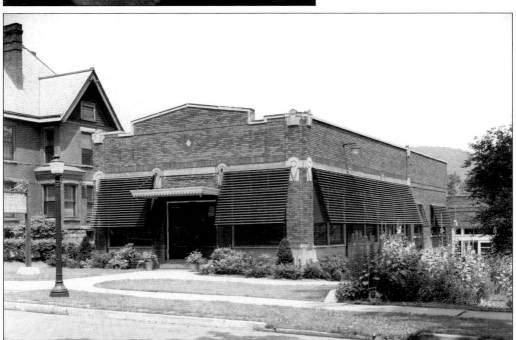

The entrance to the parts division was on East Street. A second entrance was built on Second Street in 1944. Sylvania supplied billions of parts to various industries every year.

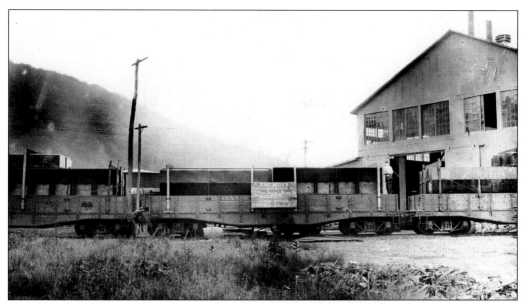

Hammond Iron Works was established by William Hammond in 1900. Its initial jobs were the construction of steel storage tanks, boilers, and other plate structures mainly for Pennsylvania oil producers. William Hammond's successor, Harry D. Kopf Sr., was largely responsible for the company's growth—both in geographic areas where its crews traveled to make field installations and in products it produced.

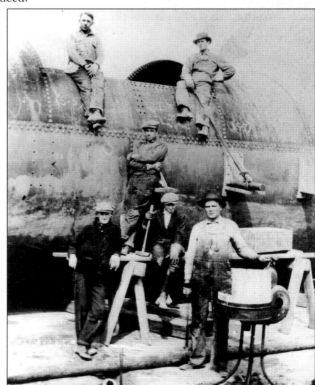

Hammond Iron Worlds sent its crews all over the country to install its products. This photograph shows a crew on a job site at Jacksboro, Texas, in 1913.

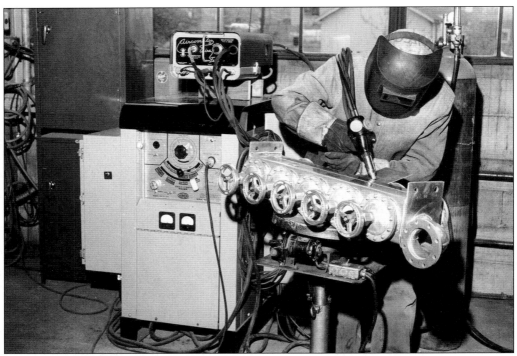

Charles Fairchild and Louis Betts formed a company in 1901 called Fairchild & Betts Founders and Machinists. The company moved to its current Pennsylvania Avenue location and changed its name to Betts Machine Company but suspended operations at its foundry facility in the mid-1940s. This photograph shows a Betts employee at work in 1958.

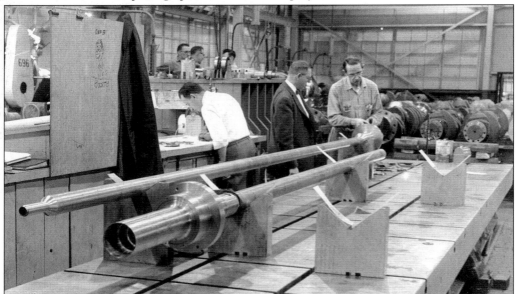

The National Forge Company was founded in 1915 with a staff of 20 workers and just a few tools and machines. The interior of the plant grew quickly to accommodate the company's expanding product lines and equipment.

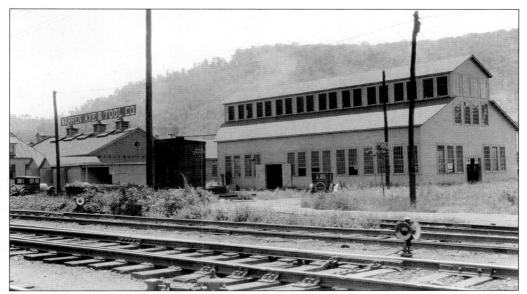

The Warren Axe & Tool Company was founded by William J. Sager, a Civil War veteran who moved to Warren with his family in 1893. Sager also patented the company's hallmark product: the Sager Special Chemical Processes Axe. The company manufactured axes as well as other products, such as hooks, handles, and grabs, that were used all over the world.

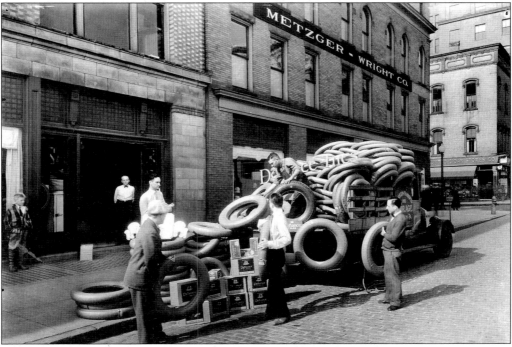

The Metzger-Wright Company, at Liberty and Second Streets, was long known as Warren County's leading department store. The company opened its doors in 1896 as Smart, Silberger, & Metzger (in the location that later housed Kresge's). This *c.* 1926 photograph shows Metzger-Wright's tire and tube sale in front of the store.

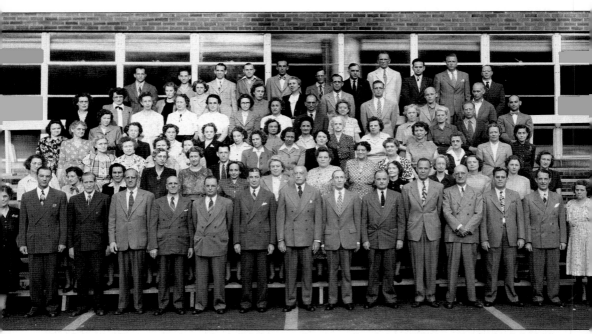

The New Process Company, which began as a direct-mail raincoat sales company by John L. Blair Sr. in 1910, has grown into one of the world's largest direct-mail enterprises, serving millions of customers annually. Among the thousands of workers New Process has employed over the years are these employees, celebrating 20 years of service with the company *c*. 1948.

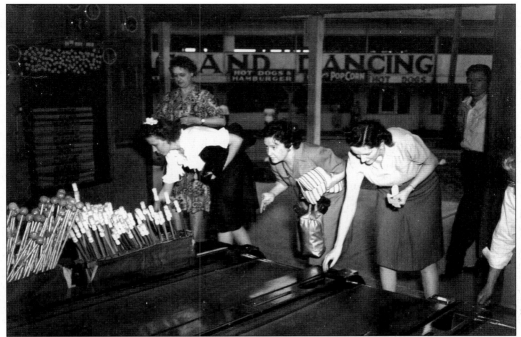

What began as a one-man operation selling raincoats primarily to undertakers grew into what is known today as the New Process Company. One of the reasons New Process is so well endeared not just by the community but also by its employees is because of the way employees are treated. One such way companies give back to their workers is a company outing or picnic. These two photographs were taken at New Process's 1945 company picnic, held on August 30 at Midway Park in Jamestown, New York.

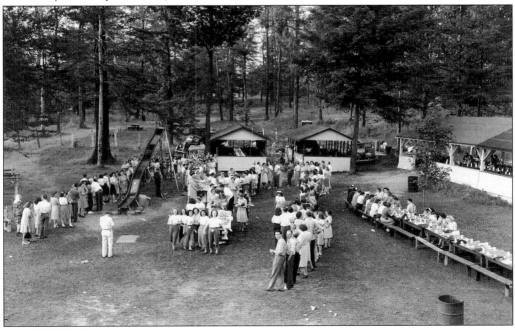

The S.S. Kresge Company, a five-and-dime store that was part of the K-Mart Corporation, stood on Liberty Street. Among the merchandise inside the store stood a popular lunch counter, which appears in this June 29, 1950 photograph.

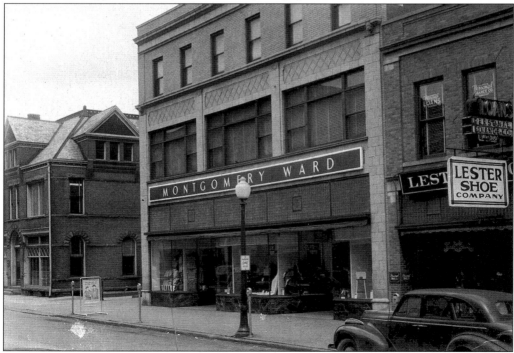

A fixture in downtown Warren since the late 1920s, the Montgomery Ward department store occupied this three-story building on Liberty Street.

"Piso's Cure for Consumption" was a well-known product. Warren's Piso Company sold its product in E.T. Hazeltine's Drug Store until demand grew so great that the company needed its own building. The company incorporated in 1894, at which point it was producing 20,000 bottles of the cure daily. The name of the Piso Company's signature product was changed to Piso's Cough Syrup in the early 1900s after a court order ruled that the company could not claim it to be a cure for consumption.

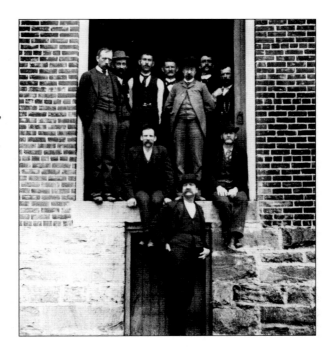

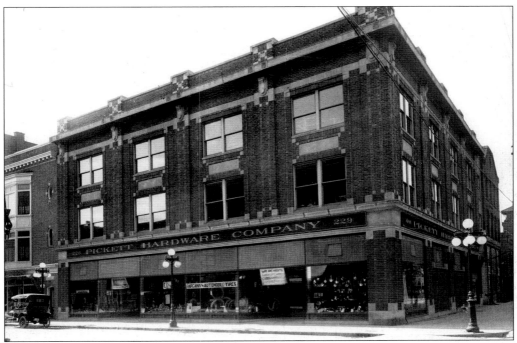

William H. Pickett came to Warren in 1865 and purchased H.A. Jamieson and Company, a hardware store, in 1880 after working with Jamieson for several years. The Pickett Hardware Company sold hardware and other products, such as bathroom fixtures, farm machinery, and stoves. Pickett moved to Pittsburgh *c.* 1900, but the Pickett Hardware Company remained in operation under its new owners, the Oil Well Supply Company of Pittsburgh.

This photograph shows the original site of the Warren National Bank, 328 Pennsylvania Avenue, where the bank conducted business from 1893 until it outgrew the location and acquired new headquarters to the corner of Liberty and Second Streets in 1903.

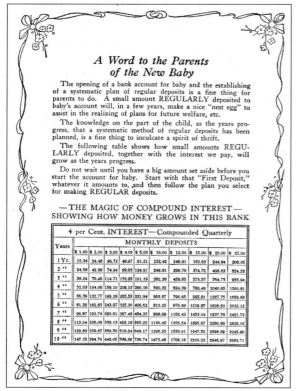

A Word to the Parents of the New Baby

The opening of a bank account for baby and the establishing of a systematic plan of regular deposits is a fine thing for parents to do. A small amount REGULARLY deposited to baby's account will, in a few years, make a nice "nest egg" to assist in the realizing of plans for future welfare, etc.

The knowledge on the part of the child, as the years progress, that a systematic method of regular deposits has been planned, is a fine thing to inculcate a spirit of thrift.

The following table shows how small amounts REGULARLY deposited, together with the interest we pay, will grow as the years progress.

Do not wait until you have a big amount set aside before you start the account for baby. Start with that "First Deposit," whatever it amounts to, and then follow the plan you select for making REGULAR deposits.

— THE MAGIC OF COMPOUND INTEREST —
SHOWING HOW MONEY GROWS IN THIS BANK

Years	4 per Cent. INTEREST—Compounded Quarterly									
	MONTHLY DEPOSITS									
	$1.00	$2.00	$3.00	$4.00	$5.00	$10.00	$12.00	$15.00	$20.00	$25.00
1 Yr.	12.24	24.48	36.73	48.97	61.21	122.42	146.91	183.63	244.84	306.05
2 "	24.98	49.96	74.94	99.93	124.91	249.81	299.78	374.72	499.63	624.55
3 "	38.24	76.48	114.71	152.95	191.19	382.38	458.85	573.57	764.75	955.94
4 "	52.03	104.06	156.10	208.13	260.16	520.32	624.39	780.49	1040.65	1300.81
5 "	66.39	132.77	199.16	265.55	331.94	663.87	796.65	995.81	1327.75	1659.68
6 "	81.32	162.65	243.97	325.30	406.62	813.25	975.90	1219.87	1626.50	2033.12
7 "	96.87	193.74	290.61	387.48	484.35	968.89	1162.43	1453.04	1937.78	2421.73
8 "	113.04	226.09	339.13	452.18	565.22	1130.45	1356.54	1695.67	2260.89	2826.12
9 "	129.83	259.67	389.50	519.34	649.17	1298.35	1558.01	1947.52	2595.69	3245.86
10 "	147.35	294.70	442.05	589.39	736.74	1473.48	1768.18	2210.23	2946.97	3683.71

The Warren National Bank, organized in 1893 under the National Banking Act, offered its customers a scrapbook-type booklet called *Our Baby's Book* in the 1920s. Pages included space for a new baby's handprint, christening notes, a family tree, and a record of gifts. The last page, called "A Word to the Parents of the New Baby," noted the importance of a bank account for the baby with regular (even small) deposits and included a chart titled "The Magic of Compound Interest."

The First National Bank was formed in Warren on August 6, 1864. The exterior of Warren's First National Bank is shown in 1944. After opening for business in Johnson Exchange, the bank moved its operations to Second Street in 1871. The bank was remodeled inside and out in 1911.

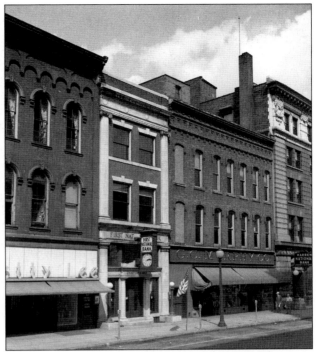

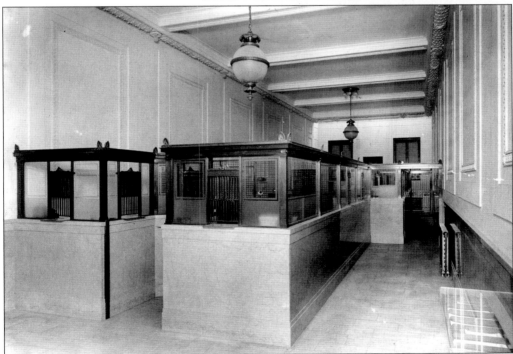

The banking room of the First National Bank was constructed to be virtually fireproof. Steel was used for desks and countertops with bronze cages, counter rails, and trimmings. The money vault in the basement was constructed of concrete and steel.

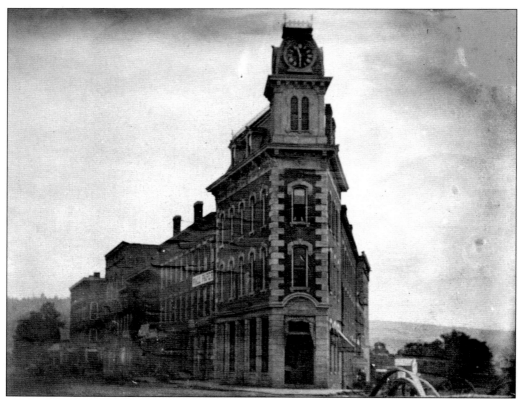

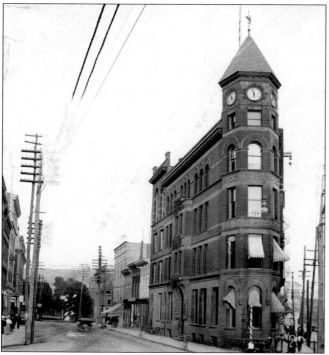

The Warren Savings Bank first opened for business on April 19, 1870, in an office in the Watson-Davis block. These two photographs show the building where it operated from 1876 until the building burned in 1889 and its replacement building in a photograph taken c. 1893, into which the bank moved in August 1891. Lewis F. Watson served as president of the bank until late 1889, when he resigned due to poor health.

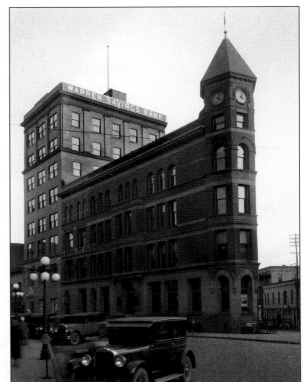

In 1926 and 1927, an eight-story addition was added to the back of the Watson-Davis block on its eastern end (right). In addition to housing businesses other than banks, the building has been home to the Warren Savings Bank (below) in its subsequent name changes (including the Warren Savings Bank & Trust Company and the Pennsylvania Bank & Trust Company).

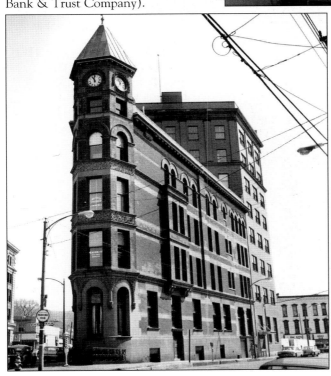

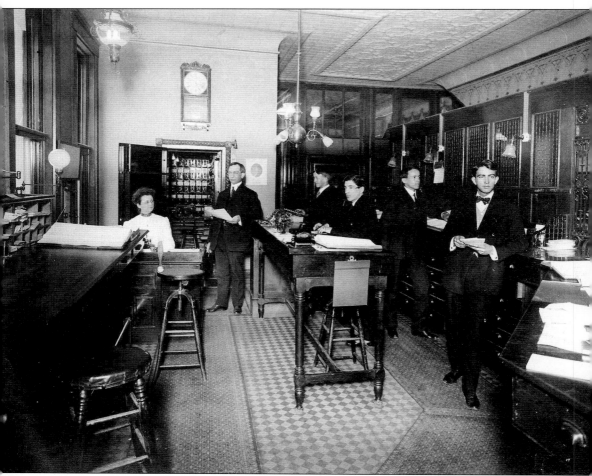

This photograph shows Warren Trust Company employees in the back room *c.* 1910. The gated windows on the right of the photograph are those that customers approached to make their transactions. The bank, organized in 1901, moved to this location in Warren's "Wall Street" in 1908.

Two

TRANSPORTATION

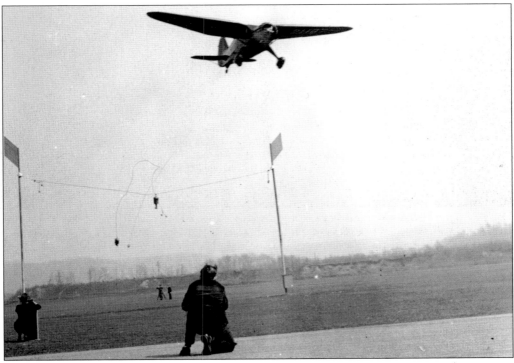

Planes, trains, and automobiles have all played a part in Warren's transportation history—as have lumber rafts, ferries, trolley cars, and horse-drawn vehicles of all sorts. The evolution of transportation affected Warren's business community and everyday life as methods, speed, and ease of delivery improved. Warren played a role in the growth of the national railroad industry in the 19th and 20th centuries. A busy depot for the Pennsylvania & Erie Railroad opened in 1869 and became a national landmark. Within the city, the Warren Street Railway Company operated trolley lines within Warren and out to surrounding cities. The Warren Airport, opened in 1930, had three runways to allow any size aircraft to take off or land in any direction. In this photograph, onlookers watch as an airmail plane flies away after making a pickup.

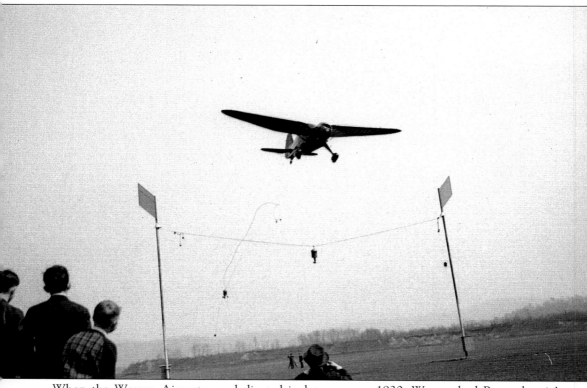

When the Warren Airport was dedicated in late summer 1930, Warren had Pennsylvania's third-largest post office (behind Philadelphia and Pittsburgh, both of which had airmail lines operating regularly out of their airports). Warren was no exception, quickly adding airmail to its list of services offered, which also included student instruction, gas and oil sales, and charter flights.

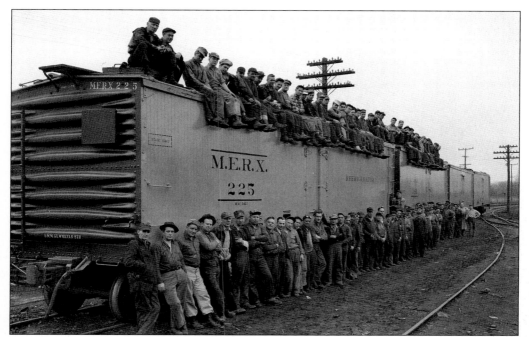

The Warren Car Company's work included repairs on boxcars, hopper cars, and tank cars, its primary customers being railroad companies. At its peak in the 1940s, the Warren Car Company employed more than 200 people, some of whom are shown with one of the cars they were charged with repairing.

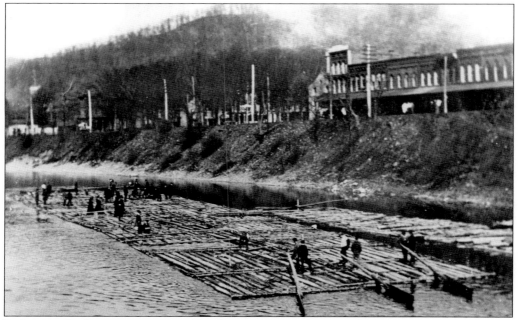

Rafting made the transportation of lumber to places such as Pittsburgh easy. This c. 1900 raft is the last known square timber raft. It was made up of pieces of wood from the Conewango Creek in the Warren Eddy.

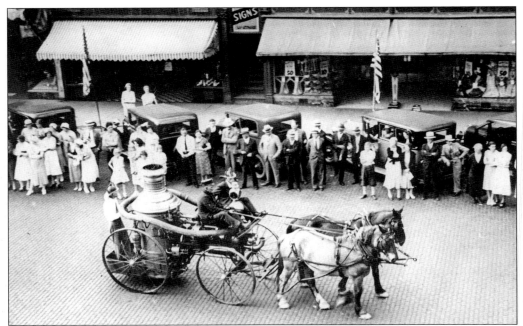

The Warren Fire Department used horse-drawn fire engines like this one until motorized fire trucks came into use. When the fire bell sounded, horses would get into position under suspended harnesses, which were then lowered onto them. The firemen would fasten the harnesses into place before climbing onto the truck and racing off.

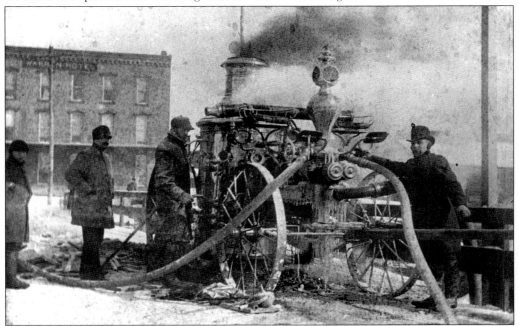

This steam fire engine, shown here in use here at the 1889 Watson-Davis block fire, was called the *Rufus P. King*. The fire engine arrived in Warren in December 1873 and was named in honor of the original member of Vulcan Fire Company No. 1, which was organized in 1853.

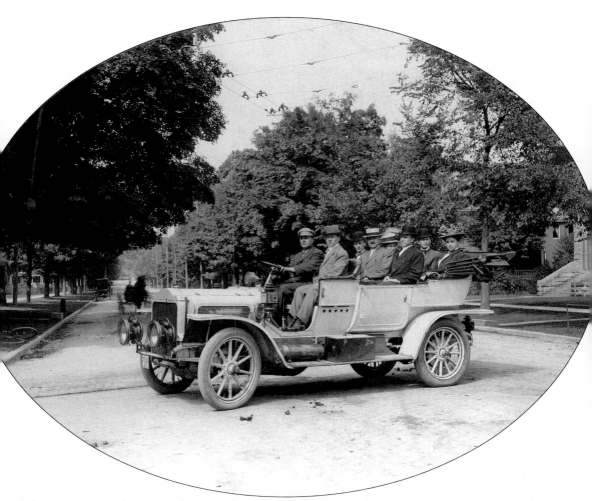

Warren citizen Charles Knabb, the driver in this photograph, was the owner of the first automobile registered in Warren County. His white steamer is shown here *c.* 1907 on Market Street near Third Avenue.

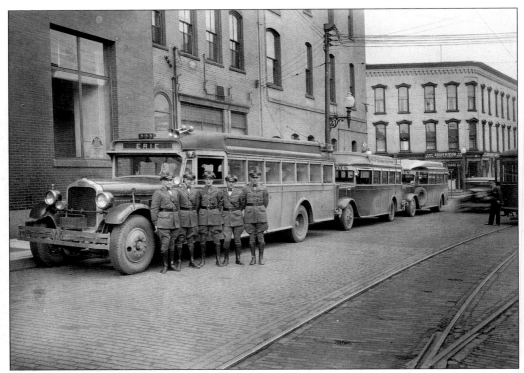

This photograph shows three buses on Pennsylvania Avenue on the south side of the flatiron building *c.* 1933. The first bus was collecting passengers for a trip to Erie.

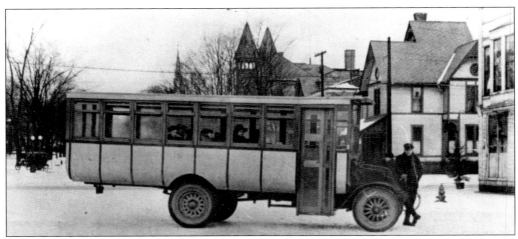

The Green Line bus ran between Warren and Starbrick. After Northwest Savings Bank used this photograph in an advertisement, the bus driver's wife called the Warren County Historical Society to say that the bus also ran to Youngsville.

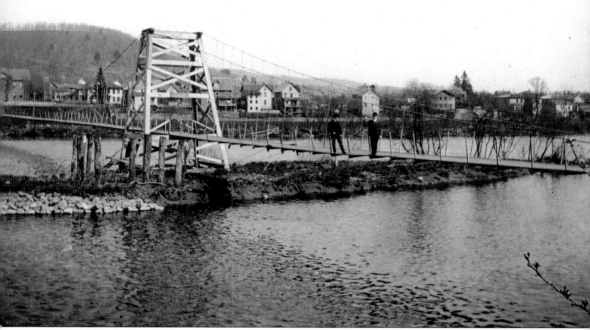

The swinging bridge was constructed for pedestrian traffic and replaced in 1904 with a bridge made of used steel. (The latter bridge was later replaced by the Third Street Bridge of today.) The swinging bridge was moved to Kelletville (Forest County) in 1906. One account recalls the danger of this type of bridge: "The planks underfoot were slippery enough in the rain and treacherous indeed with the least trace of frost. High water or ice breaking up in the creek always meant real damage to such a frail structure."

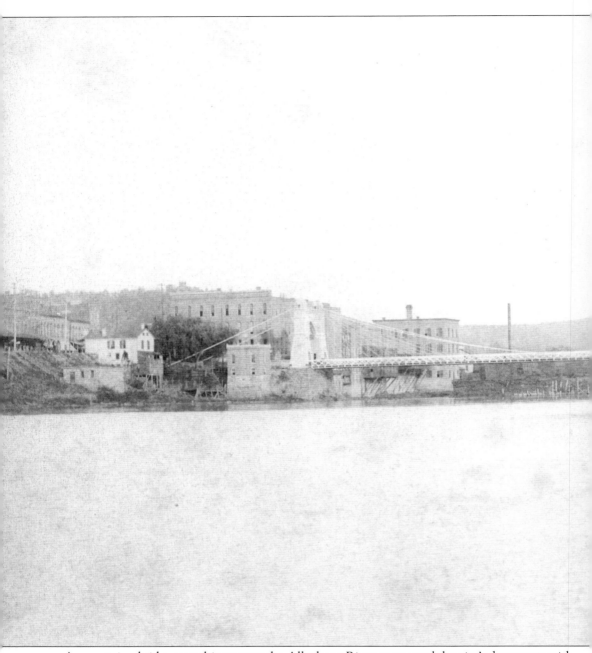

A suspension bridge stretching across the Allegheny River connected the city's downtown with the south side. The bridge began as a toll bridge and remained that way for close to 25 years. In 1894, rates were 25¢ for four-horse vehicles, 12¢ for two-horse vehicles, and 2¢ for people

(including their bicycles). A half rate was charged for funerals. After standing for 48 years (in use for 47 years), the bridge was replaced in 1918 with the current concrete structure (the Hickory Street Bridge) and was dismantled in 1919.

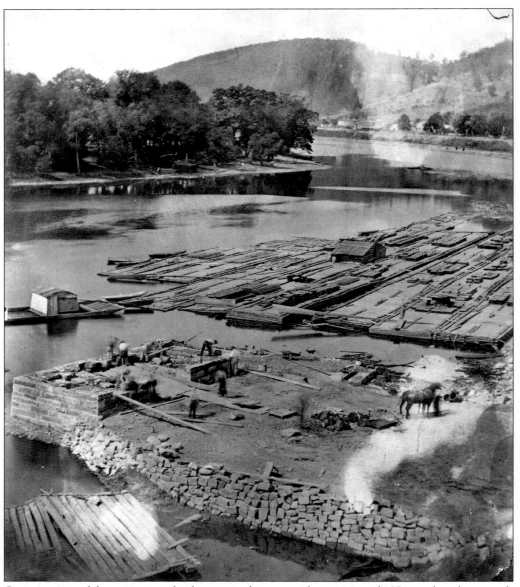

Construction of the suspension bridge was under way in the summer of 1871, as this photograph shows. Rumors that the Roebling Company would be at the helm of building Warren's bridge were unfounded, as Roebling employees were busy constructing the Brooklyn Bridge.

The suspension bridge has been credited as the "impetus for eventual development on the south side of the river." It was dismantled in 1919, the concrete bridge having been completed in 1918.

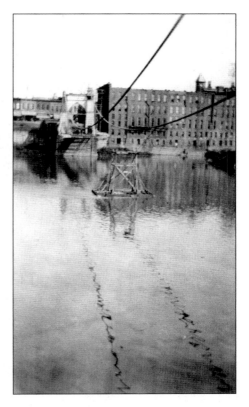

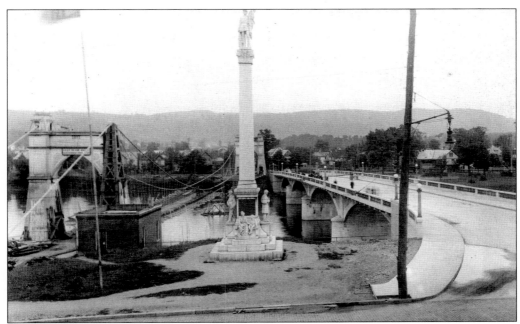

This unique photograph shows both the suspension bridge and its replacement, the concrete Hickory Street Bridge, which was erected in 1918 and is still standing.

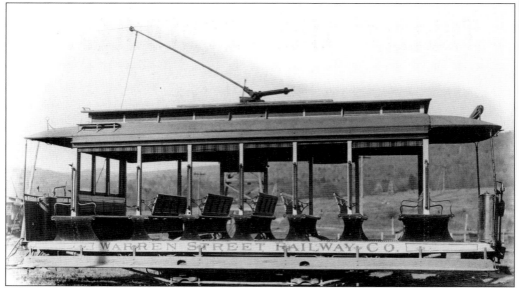

Car No. 5 of the Warren Street Railway, one of the first open cars purchased by the company, is shown here. Nos. 5 and 7 were open because they had been converted from horse cars that were part of an obsolete transportation line. Naturally, these cars were also referred to as summer cars because they were more visible in the summertime.

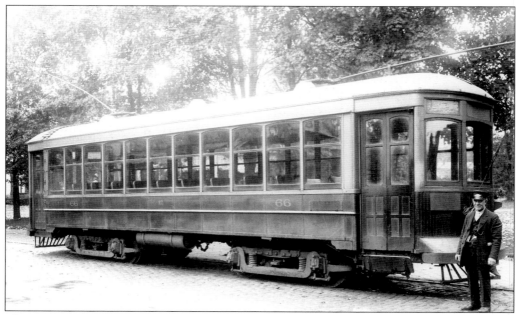

The Warren Street Railway operated from 1905 to 1928 between Warren and Sheffield, and until 1929 between Warren and Jamestown, New York (along the Warren & Jamestown Street Railway of Pennsylvania lines). Trains traveled at an average of 50 miles per hour. Local lines ran from 1893 until 1930.

TROLLEY LINE SCHEDULES.

City Main Line.

Main line cars leave Struthers Hotel and Gladerun every 15 minutes on even division of hour, and P. & E. depot seven minutes, 22 minutes, 37 minutes and 52 minutes after even hour.

Conewango Avenue Line.

Conewango car leaves West End 52 minutes past even hour, leaves Struthers Hotel, going east, on even hour and 23 minutes past even hour. Leaves Conewango avenue terminal 12 minutes and 34 minutes after even hour.

North Warren Line.

Cars leave Struthers House for North Warren on hour and half hour, leave North Warren 15 minutes and 45 minutes past even hour.

Warren-Sheffield Cars.

Main line cars leaving Struthers House 15 minutes after the hour connect cars at Gladerun for Stoneham, Clarendon, Watson, Tiona, Saybrook and Sheffield. Cars leave Sheffield at 30 minutes after even hour for Warren.

Warren-Jamestown Cars.

Beginning 6 a. m. car will leave Warren for Jamestown hourly on even hour. Last car from Warren to Jamestown 10 p. m.

First car leaves Jamestown for Warren 6:25 a. m. and next car at 7:30 a. m., after which time cars will leave Jamestown for Warren hourly at 30 minutes past even hour until 9:30 p. m., after which time there will not be a car for Warren until the last one, which leaves at 11:10 p. m.

The *Warren Mail* printed Warren's trolley schedules on January 3, 1907. As the schedules indicate, trolleys took passengers to Sheffield, North Warren, and Jamestown, and enabled them to connect with the major railroad lines to Philadelphia, Erie, Pittsburgh, and points beyond.

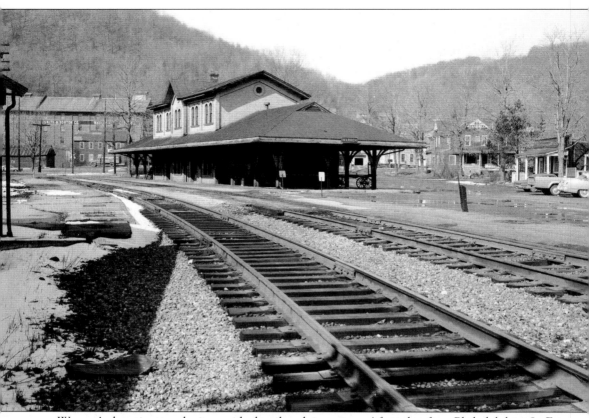

Warren's location made it an ideal railroad junction. After the first Philadelphia & Erie Railroad train passed through Warren on August 15, 1864, plans were under way for a depot. The depot opened in July 1869, and the last passenger train passed through in 1965.

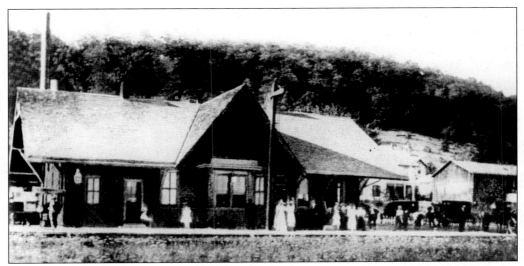

Because Warren was serviced by the major railways of the day and home to 22 passenger trains daily by 1895, a passenger station was essential. The Dunkirk Allegheny Valley & Pittsburgh station at Fourth and Laurel Streets was the third of its kind in Warren. Built in 1893, the station followed two others, both at Fourth and Beech Streets.

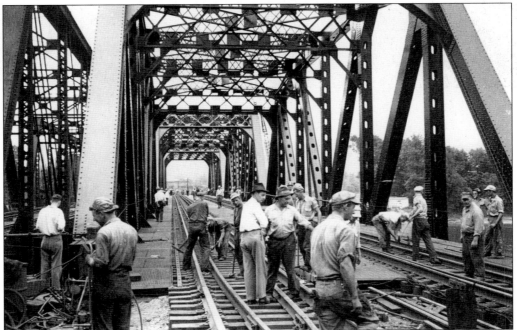

The Pennsylvania Railroad bridge across the Allegheny River was built in 1896. A replacement became necessary as modern railroad equipment became so much heavier than that of 1896, forcing speed restrictions over the bridge. In this photograph, taken on August 17, 1949, the day the bridge was replaced, part of the new bridge is visible at the left. Cranes and block pulleys were used to move the new bridge into place while simultaneously moving the original structure aside. The old bridge was taken apart and sold as scrap metal. A Struthers-Wells yard engine was the first to cross the new bridge, just hours after the switch was complete.

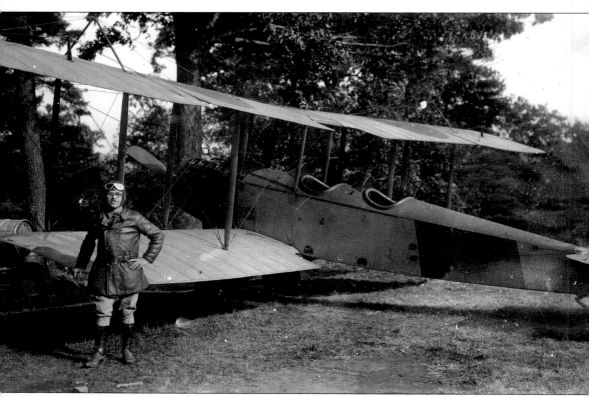

This unidentified aviator worked at the landing and takeoff field located at the top of Central Avenue and Canton Street in the 1920s. People paid $10 to $15 for 15-minute flights in a biplane to get an aerial view of Warren.

Three
PEOPLE AND PLACES

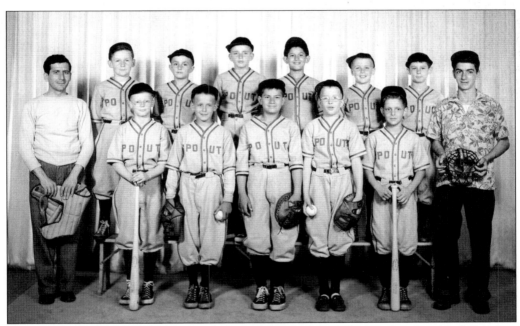

Some of Warren's early leaders—including philanthropists Thomas Struthers and Caroline Eldred Watson, doctors M.V. Ball and William Hazeltine, and oil magnates David Beaty and Henry Rouse—deserve recognition for their contributions to the city. The Carver House, the Struthers Library building, and the Watson-Davis block are among Warren's early landmarks. However, influential people and extraordinary places are not limited to Warren's earliest days. Fire department members, Warren State Hospital nurses, local business–sponsored Little League teams (such as this 1950 team, sponsored by the West Penn Oil Company), Salvation Army Bible School attendees, the Sailors and Soldiers Monument, the Warren County Fairground, the Watson Memorial Home, and the courthouse came along later but are just as much integral parts of the community.

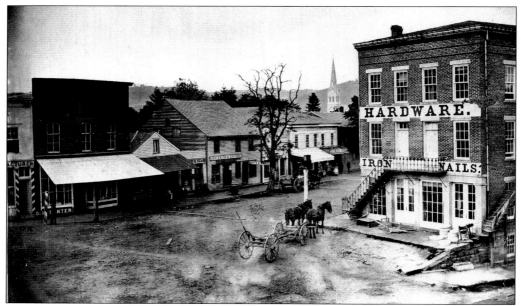

These two photographs offer a good representation of roads in the latter half of the 1800s. The first shows downtown's Watson-Davis block in 1868. The other shows the intersection of Conewango and Pennsylvania Avenues.

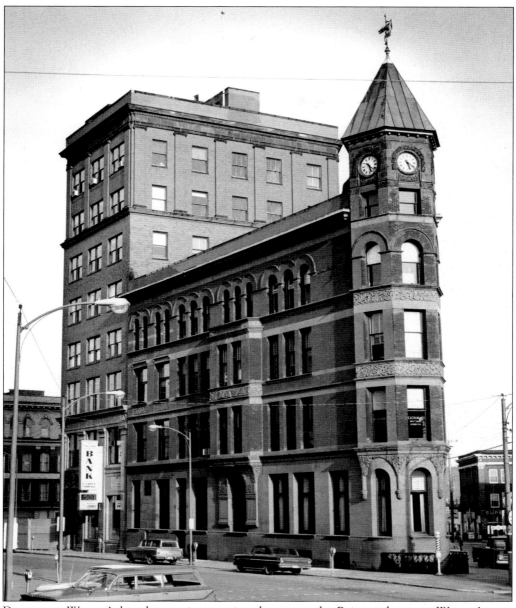

Downtown Warren's best-known intersection, known as the Point, is home to Warren's own flatiron building, which has served as home to numerous business enterprises over the years.

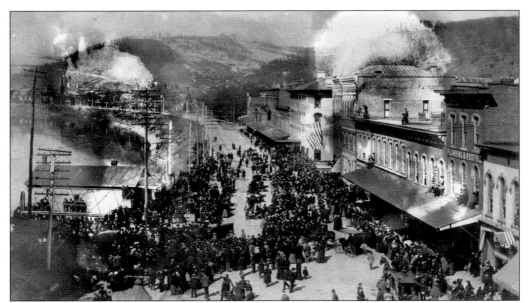

In 1898, funerals were held for members of Warren's National Guard unit, Company I of the 16th Pennsylvania Infantry, some of whom perished in the Spanish-American War. This photograph shows the crowded downtown scene, as people gathered to watch the parade of hearses go by en route to Oakland Cemetery across the river.

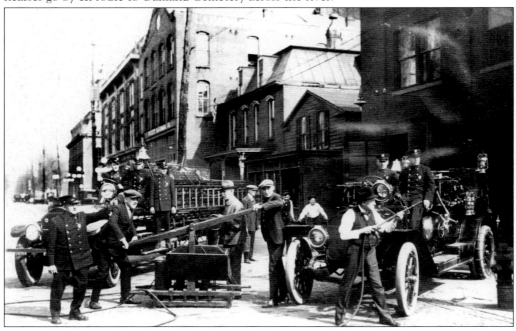

Motorized fire trucks replaced horse-drawn firefighting vehicles *c. 1920*. Warren's Central Fire Station used both pumper and hook-and-ladder trucks. The pumpers' hard tires were later changed to pneumatic tires. One of the station's fire trucks, the *Rufus P. King,* was a steam engine that arrived in Warren in 1873. It was named after one of the original members of Warren's Vulcan Fire Company No. 1, which organized in 1853.

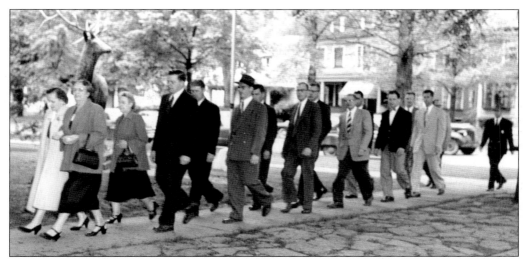

One of Warren's most shocking moments came in January 1954 when Judge Allison D. Wade was fatally shot in his courtroom by Norman Moon, a man whom Wade had earlier seen in a divorce case. (Moon had been ordered to pay what many people considered an unfair amount of support.) Judge Alexander C. Flick Jr., who presided over the case, called this group of jurors "a courageous lot." They are shown in June 1954 on Hickory Street on their way to the courthouse.

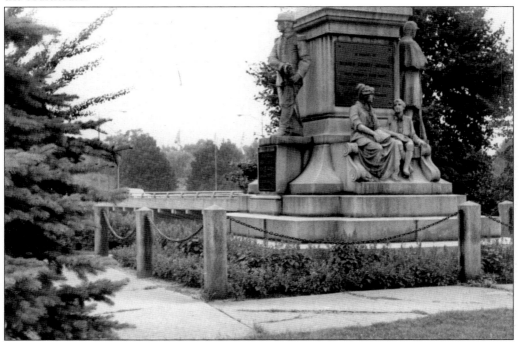

The Soldiers and Sailors Monument, the base of which is shown here, was dedicated on November 4, 1909. Among the bronze tablets inscribed with the names of Warren County veterans is one that reads, simply, "In memory of Warren County heroes. They fought the good fight. They kept their country's faith. We cherish their memories." A parade ended at the monument site but the dedication ceremony was moved indoors due to heavy rain.

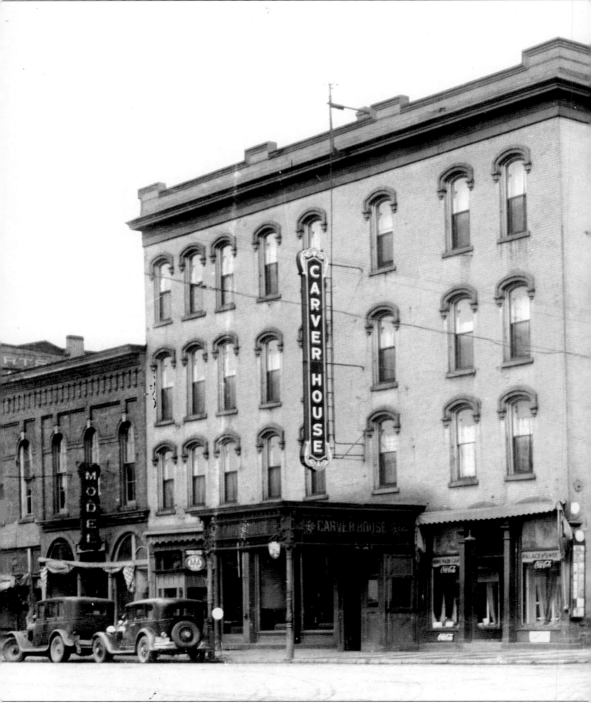

The Carver House dominated the intersection of Hickory and Water Streets from its opening in 1849 until it was destroyed by fire in 1956. It was built on the former site of the Warren House Hotel, which was torn down in 1848, and had many owners. Guests of the Carver House

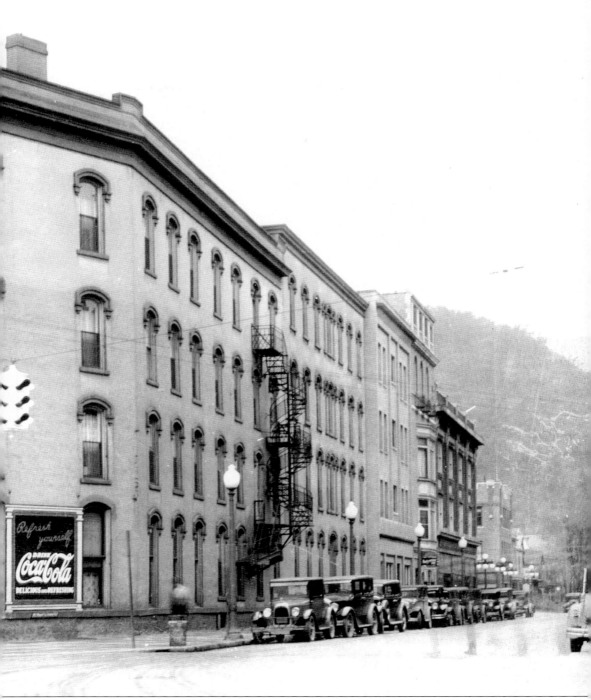

paid $2 per night in Carver House's early days and are said to have included oil tycoon John D. Rockefeller and U.S. president and Civil War general Ulysses S. Grant.

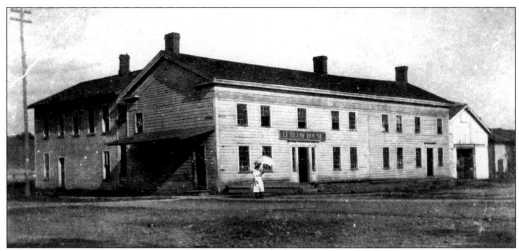

Standing on the corner of Market and Second Streets, the Ludlow House was one of Warren's early hotels. It was torn down in 1897 when the high school was built on that site. Market Street Elementary School currently stands on this site.

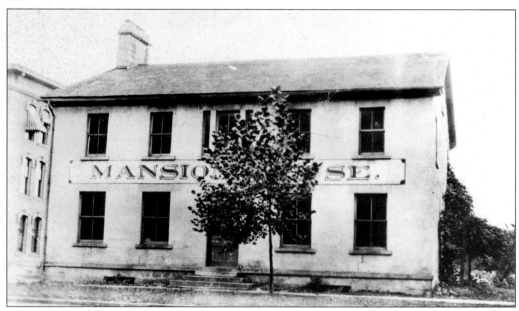

Archibald Tanner had the original Mansion House built. The Mansion House closed as a tavern in 1856, at which point its bell was moved to the Tanner House on Fourth Avenue. The bell, according to many, served as Warren's town crier for many years. That building was originally used by Robert Falconer as the Lumbermen's Bank. When the bank failed in 1837, Falconer sold the building to Tanner, and it became the Tanner House. The name was changed to the Diamond House in 1845 and then later to the New Mansion House when the original Mansion House closed.

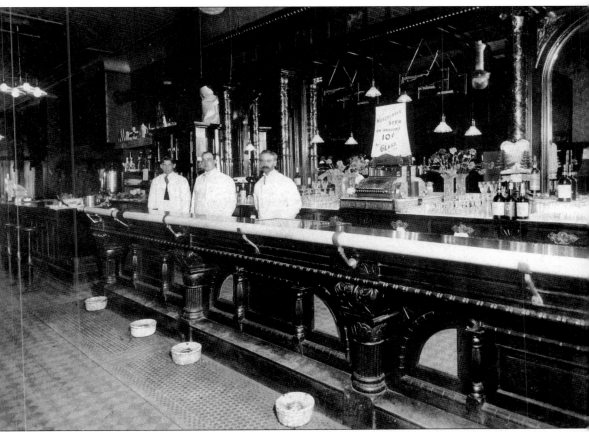

The Revere House was built on Pennsylvania Avenue east of the Pennsylvania Railroad in 1872. This was an ideal location for a hotel, as railroad traffic was on the rise. Ownership changed hands several times over the years. This photograph shows the Revere House bar when the hotel was under Patrick Madden's ownership.

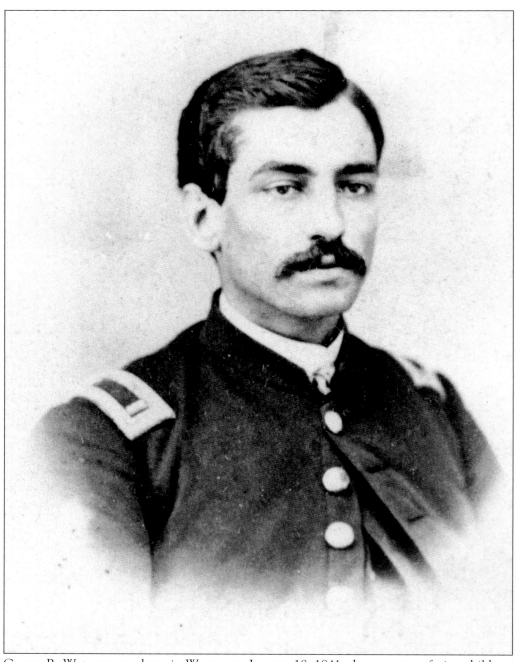

George R. Wetmore was born in Warren on January 18, 1841, the youngest of nine children. He was a member of the first graduating class of Pennsylvania State University and was a leading organizer of the Pennsylvania Gas Company. He married Anna Eliza Struthers, daughter of the prominent Thomas Struthers, in 1870. This photograph, taken when Wetmore was 21 years old, shows him in his Civil War uniform.

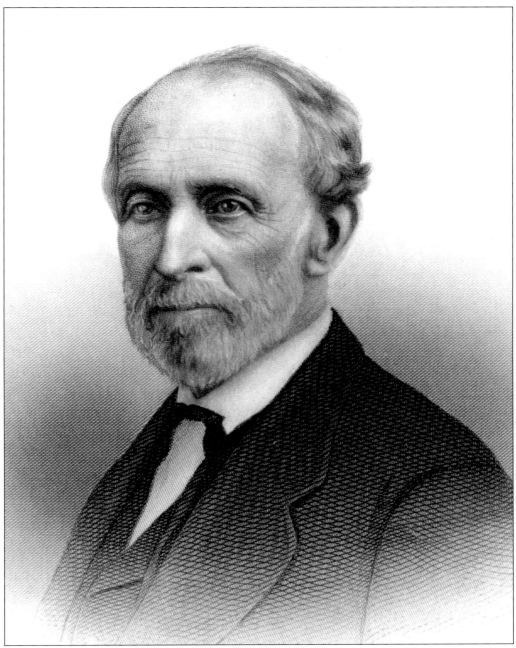

Thomas Struthers, who came to Warren in 1828, remains one of the most important people in Warren's history. In addition to being integral in getting railroads in Warren, he was a lawyer, prominent businessman, and philanthropist. According to J.S. Schenck's *History of Warren County*, "The work for which he will be longest remembered is the magnificent structure known as the Struthers Library Building, which was built for the borough by Mr. Struthers in 1883."

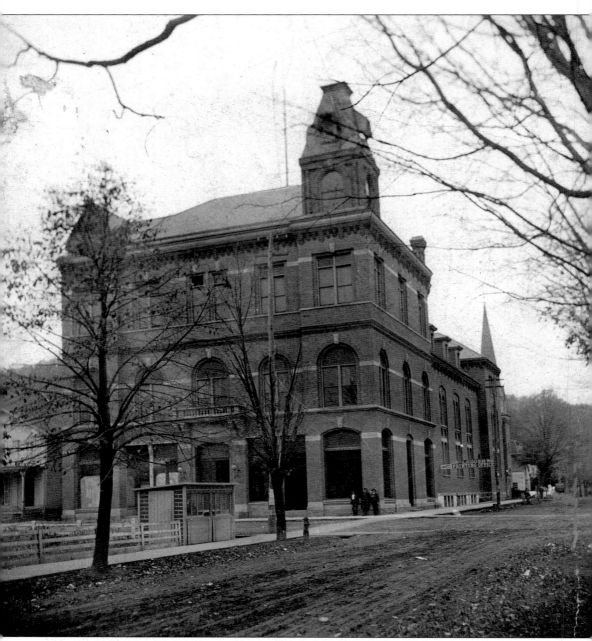

The Struthers Library Building, at the corner of Third Avenue and Liberty Street, was financed by Warren resident Thomas Struthers, who offered to build a public library for Warren in 1882. The building was designed to include rental space, providing financial support for the library. When the building opened in 1883, one such space for rent was Library Hall, Warren's opera house. Except for renovations, the structure has never been closed, making it the country's 18th-oldest operating historic theater.

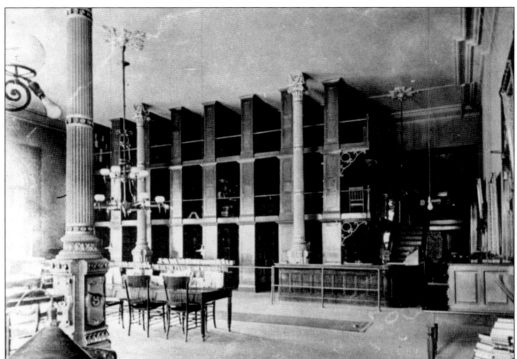

The public library was the focal point of the Struthers Building at its inception. Located on the second floor, the library room contained reading tables and chairs, a brass gasolier, book stacks 20 feet deep, and a checkout counter. This space served as the library until 1916, when the library on Market Street opened.

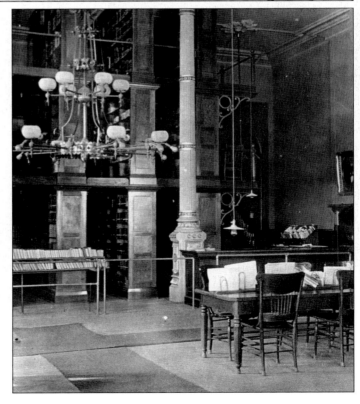

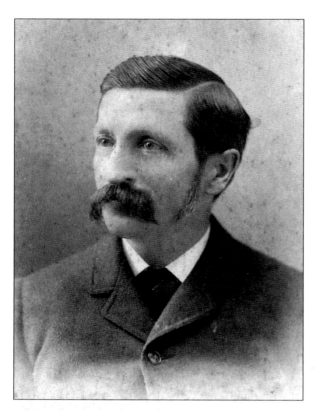

Dr. William V. Hazeltine was one of the organizers of the Warren County Medical Society on May 21, 1871. Hazeltine was the son of Dr. Abraham Hazeltine, one of Warren's earliest physicians, and the brother of A.J. Hazeltine.

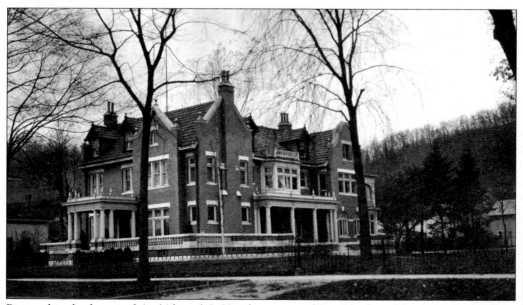

Pictured is the home of A. (Abram) J. Hazeltine, son of Dr. Abraham Hazeltine. Located on Pennsylvania Avenue West, the house was completed in 1907. Hazeltine's daughter Grace was married here. The American Legion acquired the house in 1928 and used it for nearly 40 years.

Dr. Michael Valentine Ball, son of Warren clothier George Ball, was born in 1868. He apprenticed in the pharmacy of the Davis Drug Store before attending Jefferson Medical College. In 1897, Ball became Warren's first specialist (in ophthalmology). In addition to his medical practice, Ball was active in the Social Science Club and the Warren County Medical Society. He died in 1945.

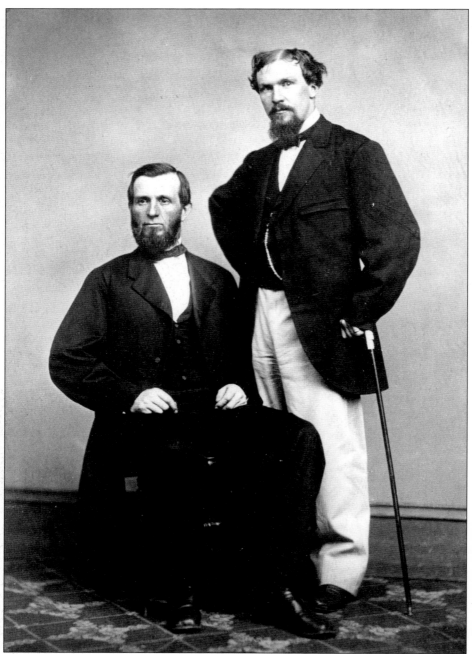

The Cobham family, which came from English aristocratic decent, arrived in Warren in September 1835 after fleeing England because of debt and for breaking church law. (George Ashworth Cobham married his brother's widow, Catherine Curry Cobham, an illegal offense, in 1828.) With the two of them came Henry and George Ashworth Cobham Jr. (George's nephews-turned-stepsons), shown here, and Georgina, daughter of George A. and Catherine Curry Cobham. After a stay at the Mansion House, the Cobhams purchased the land that came to be known as Cobham Park.

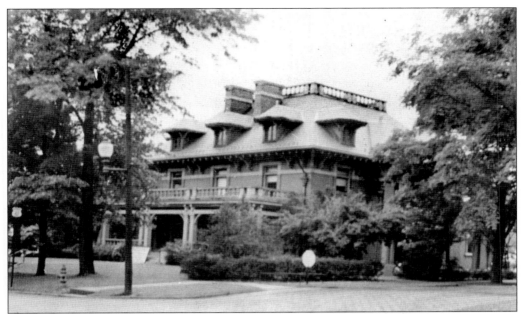

This photograph shows Jerry Crary's residence at Sixth Avenue and Market Street. Crary purchased three lots at this location in 1900; the house was finished in 1903. The accompanying barn and carriage house (not visible in this photograph) was built behind the house (facing Sixth Avenue). The home was razed in 1937, one year after Crary's death, but the barn remained.

Jerry Crary was born in New York State in 1842 and married Laura Antoinette Dunham in 1870. He and his family moved to Warren in 1902 from Sheffield, where he was a partner of Horton, Crary, & Company. Prior to this, Crary served in the Civil War until he was injured at Resaca, Georgia.

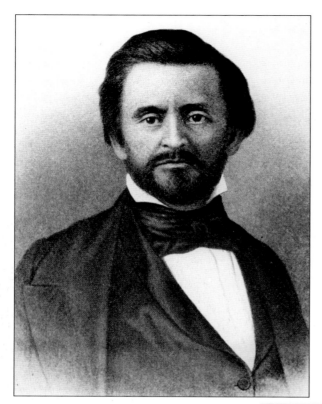

Henry Rouse, born on October 9, 1823, left his hometown, Westfield, New York, in the late 1930s. He stopped in Warren briefly before moving on to Tidioute, where he became a schoolmaster, general store owner, then state congressman representing Warren and Crawford Counties. His involvement in the oil industry was short, profitable, and ultimately deadly for Rouse. He died on April 17, 1861, in an oil explosion, leaving money in his will to improve Warren County roads and to establish the Rouse Home.

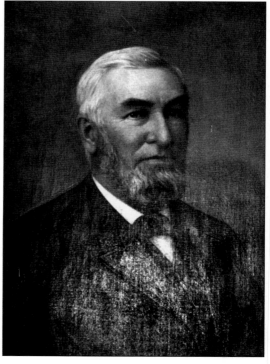

David Beaty, born in 1811 in Beaver County, moved to his mansion on Conewango Avenue in 1873. He built his fortune through hard work. He left Beaver County for Kiantone (in Chautauqua County), where he lumbered in winter and farmed in summer for four years. Beaty's next home was in Sheffield, where he worked in logging. He married in 1843 in Deerfield Creek, where he built a mill.

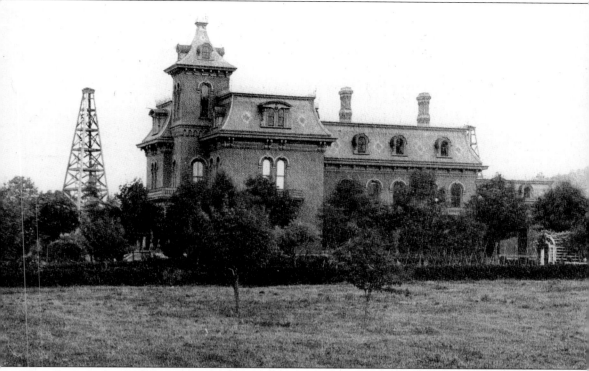

This photograph of the David Beaty home shows the second oil well he drilled, located in his wife's flower garden (he was looking for natural gas to heat his home). Beaty's vision for his house was simple: "It must be twice as large in every dimension as the house of Boon Mead." Mead, Beaty's brother-in-law, was president of the First National Bank, not to mention a successful lumber and oil businessman.

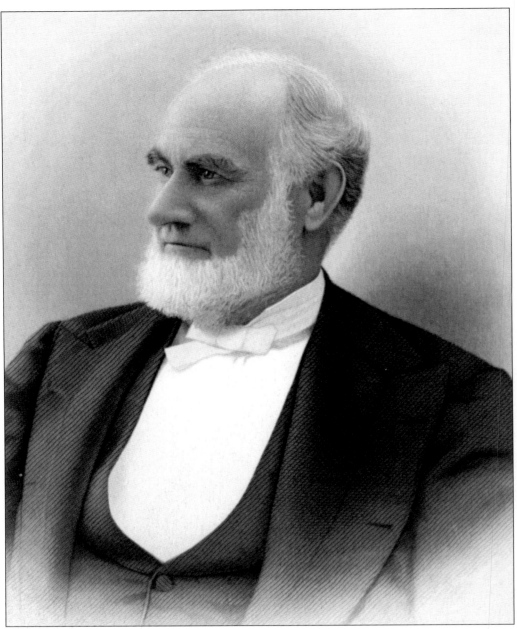

Lewis Findlay Watson was born in Titusville on April 14, 1819. He came to Warren in 1836, following Parker McDowell, for whom he worked as a clerk and who had come to Warren to partner with his brother-in-law Archibald Tanner. Watson attended Warren Academy and later became well known as a Warren merchant, lumberman, and banker. His activities included organizing and being president of the Warren Savings Bank in 1870 and serving as a Republican congressman in the late 1870s and through the 1880s.

Caroline Eldred Watson became the second wife of Col. Lewis Findlay Watson on June 18, 1856. She was born on April 20, 1836, and died on January 6, 1919. Upon her death, she bequeathed money for a women's home to be founded, built, and maintained.

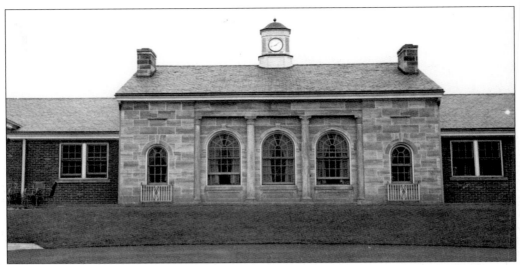

In her will, Caroline Eldred Watson bequeathed what we know as the Watson Memorial Home, which opened on July 8, 1935. The will specified a home for "indigent woman of 65 years or older and without a spouse." Her other condition was that residents want to come to live at the Watson Memorial Home. The bulk of her estate (in excess of $1 million) was used to establish the home, shown here.

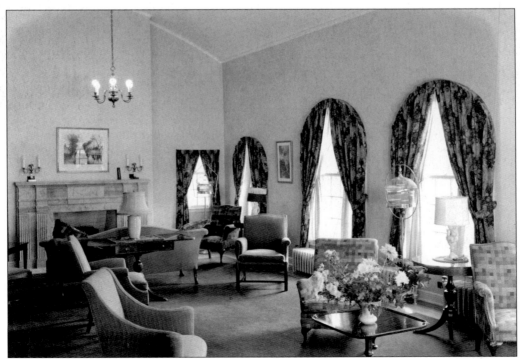

This interior photograph of the Watson Memorial Home was taken in the 1930s. When the facility opened in 1935, it had several public areas for residents' use, including four parlors and a reading room.

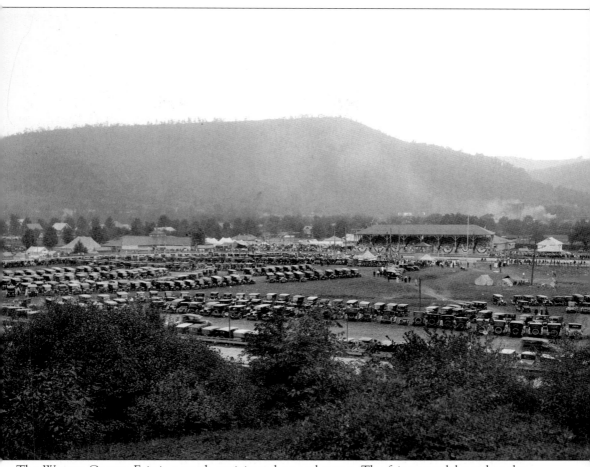

The Warren County Fair is a much anticipated annual event. The fair was celebrated at the Conewango Avenue fairgrounds in 1928. Fireworks, concessions, horse shows, and sulky races comprised some popular 1920s fair events. Prior to this site, the fair was held at the south side fairgrounds, the present site of the Warren General Hospital.

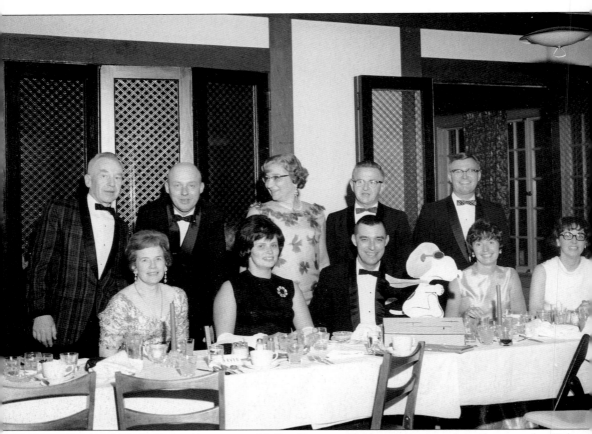

On April 22, 1947, the Conewango Valley Country Club commemorated a milestone: the 50th anniversary of its founding. Present at the celebratory dinner included these couples. Shown are, from left to right, the following: (front row) Kay Frantz, Louise Hill, William M. Hill Jr., Barbara Tracy, and Jean Gibb; (back row) James Frantz, Robert Gibb, Janey Kay, Gordon Kay, and Carl Tracy.

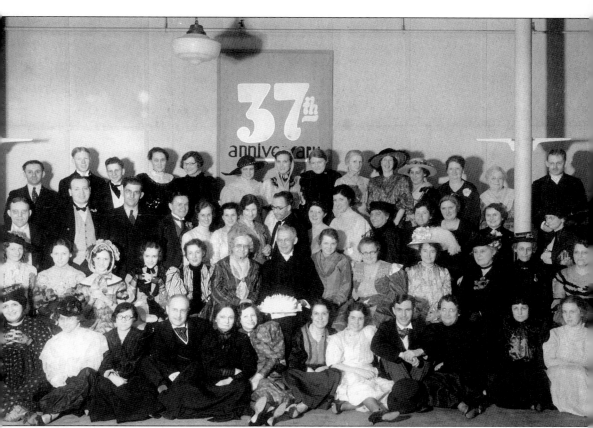

Metzger-Wright opened in 1896. This group of employees is celebrating the store's 37th anniversary in 1933.

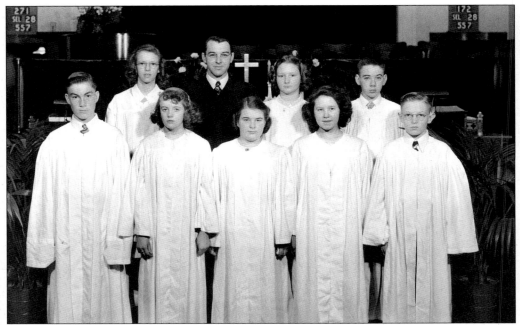

This photograph, taken on March 21, 1948, shows the 1948 confirmation class at Emanuel United Church of Christ. Rev. William T. Lane served the church as minister from 1944 until 1957.

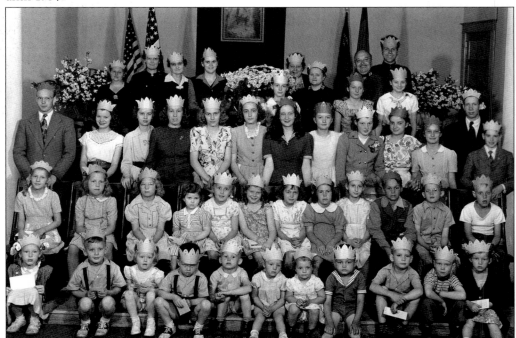

Among Warren's summertime traditions is Bible school. Groups of various ages attended the Salvation Army Children's Summer Bible School in June 1947. The Salvation Army, long a community presence in Warren, is part of the Universal Christian Church.

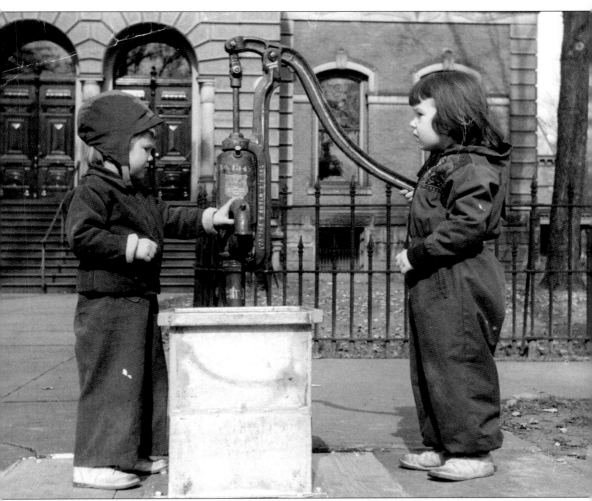

Sally Wilson (left) and Mary Cashman (ages 2 and 3, respectively) play in the town pump in front of the courthouse in early November 1949. This photograph was arranged by Martha Hill Wilson, the *Erie Post-Gazette* reporter who covered Warren County.

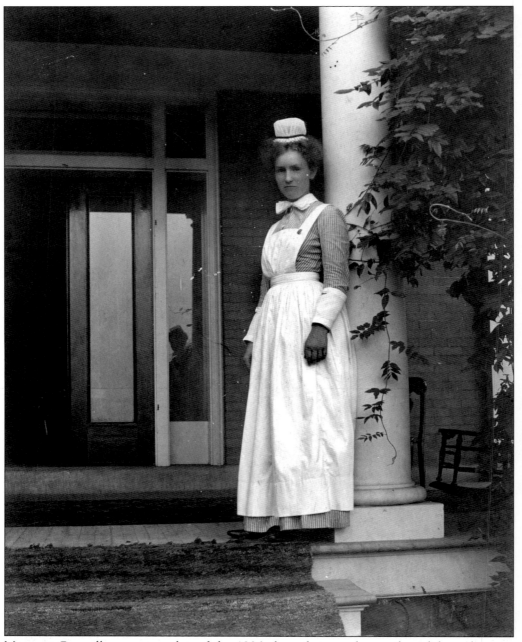

Margaret Connolly was a member of the 1906 class of nurses that graduated from the state hospital. She went on to become a Red Cross nurse in Stockton, California, and served in Europe during World War I.

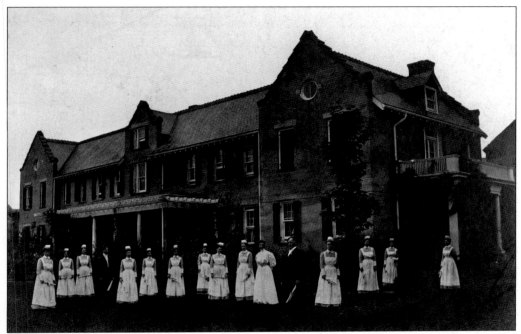

Among the graduates of the Class of 1906 of the Warren State Hospital's nursing school is Margaret Connolly, seventh from the left. The first class of nurses graduated in 1903.

Warren Emergency Hospital nurses lived dormitory-style in this building, completed in 1906. The building was named after Eliza I. Henry, who contributed funds to build the site.

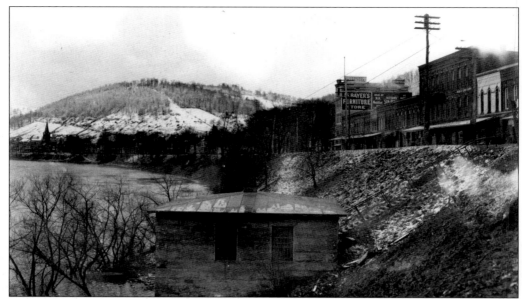

Warren's borough jail (or lockup, as it was commonly called) was a small building practically on the Allegheny River across from where the Warren General Hospital now stands.

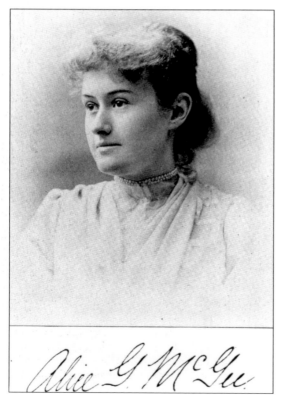

Alice G. McGee was born in Warren on February 8, 1869. She became Pennsylvania's second female lawyer and was admitted to practice law in Warren County on May 13, 1890. Two years later, McGee left law to become an actress. She died in Warren on August 11, 1895.

Charles Warren Stone was born on June 29, 1843, in Groton, Massachusetts. After graduating from Williams College in 1863, Stone came to Warren as the principal of Union School. After working in education for several years, Stone became a lawyer; he was admitted to Warren County courts in December 1866. In 1869, Stone was elected to the U.S. House of Representatives to represent Warren and Venango Counties. He next served in the Pennsylvania state senate for three terms and then as Pennsylvania's lieutenant governor. Stone married Elizabeth Moorhead of Erie in 1868. All six of their children were born in and settled in Warren. Stone died on August 15, 1912.

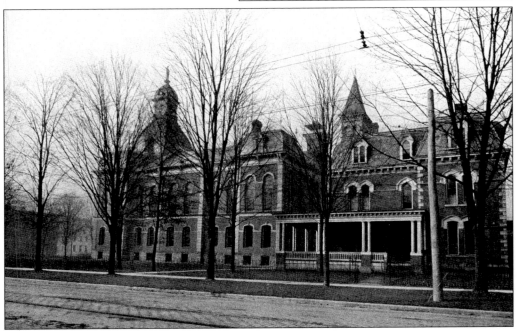

Court was first held at the courthouse in December 1877. Before this building was constructed in 1876 and 1877 to house the courthouse, jail, and sheriff's office and residence, they were all housed separately. A smaller courthouse (referred to as "unsightly and old-fashioned") stood on this same location before being replaced by this one, constructed in modern Italian Renaissance architectural style.

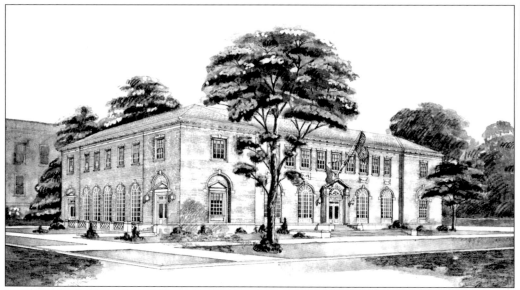

In 1932, the Warren Post Office moved to its location at Third and Liberty Streets. Congress approved construction of a federal building in Warren in 1928, after postal volume had grown steadily for several years (attributed, in part, to New Process's growth). The post office had been established in Warren in 1816 and called the Brokenstraw post office. The name was changed to the Warren Post Office on December 4, 1819, and Archibald Tanner was named postmaster. From that time until the building shown here was completed, the location of the post office varied (depending upon the postmaster).

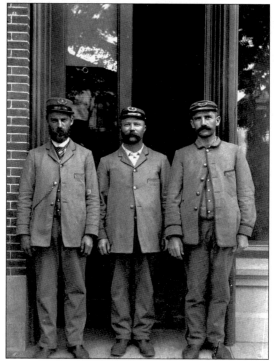

Warren's first mail carriers are, from left to right, Louis Giegerich, John Russell, and Frank Witz. July 1, 1887, marked the beginning of mail delivery service in Warren; rural delivery service was added on November 2, 1903. The mail carriers earned $600 annually.

Four

COMMUNITY

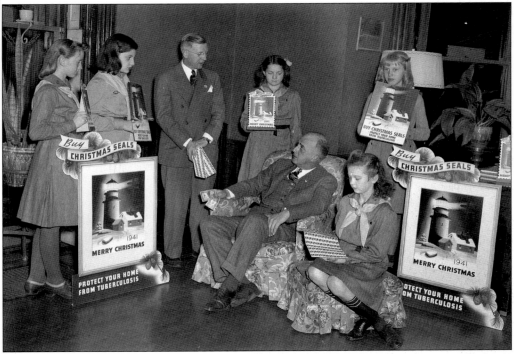

Since Warren's inception in 1795, Warrenites have always pitched in for the common good and made sacrifices to help their fellow citizens, whether that help come in the form of time, money, or goods. Here are just a few examples: When the Warren Relief Association put milk bottles throughout the community to collect money for milk for children whose families could not afford to buy it, the community responded. When the YMCA burned down and money was needed to build a new building, the community rose to meet the challenge. When the Kiwanis Club held a clothing drive, countless boxes of clothing were collected for distribution. When the Christmas Seals operation needed assistance in Warren (as seen here), Warren's Girl Scouts gladly rose to the challenge.

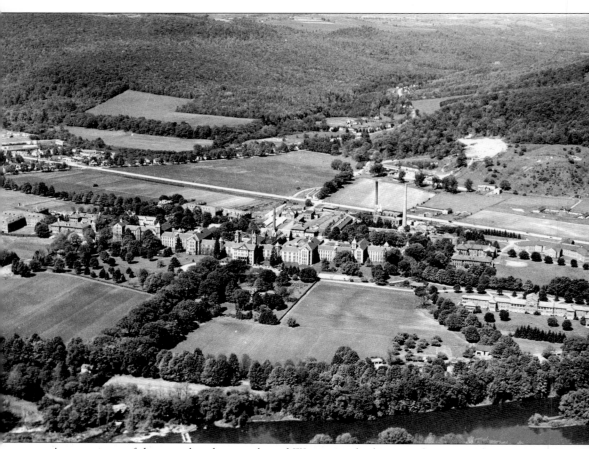

A committee of the state legislature selected Warren as the location for a mental institution to accommodate 750 patients from 10 Pennsylvania counties. Ground was broken for the State Hospital for the Insane in April 1874, and the governor was among those present when the cornerstone was laid. Since its opening in 1880, the state hospital has grown in size and scope. Patients from 13 northwestern counties are now treated here; the hospital leases space in some to other human-service agencies; and the (now) Warren State Hospital is one of nine such establishments in the state.

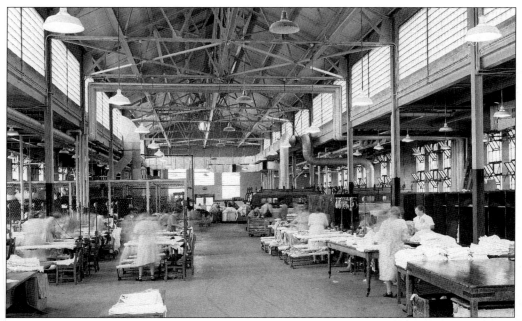

When the hospital opened its doors in 1880, one of its three buildings was the laundry building, which was connected via tunnel to the main building. The laundry building consisted of laundry facilities for the hospital, a kitchen, and other rooms.

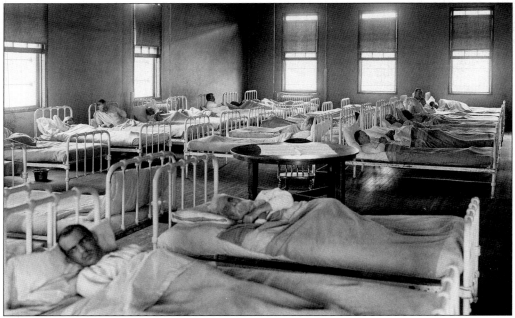

Patient wards, one of which is shown here, were housed in what was then called the Kirkbride Centre Building (now simply the Center Building), the first structure built on the state hospital grounds. (Kirkbride is an architectural style whereby construction begins at the ends of a building and works inward toward the center of the building.) Because of the building's placement, sunlight reaches every room at some point each day.

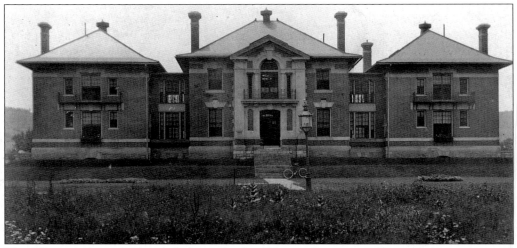

The Warren General Hospital, formerly the Warren Emergency Hospital (the name was changed in 1915), is located on Warren's south side on property previously owned by Gen. William Irvine. The hospital was built beginning in 1900 by Chris Uhdey, who was born in Germany in 1854 and who was a member of Warren's First Lutheran Church and Conewango Club. Uhdey also helped to build the state hospital, as well as many other sites in Warren. July 11, 1901, marked the hospital's first visiting day for the public, and approximately 700 visitors took part.

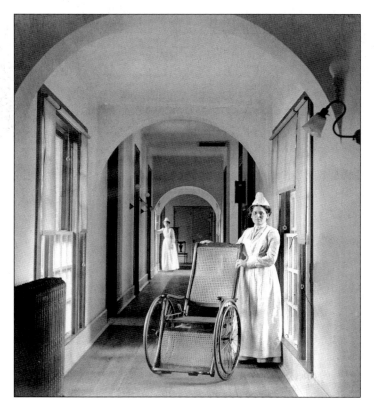

This photograph, which probably dates from c. 1910, shows a Warren Emergency Hospital nurse with a wheelchair used to transport patients within the hospital.

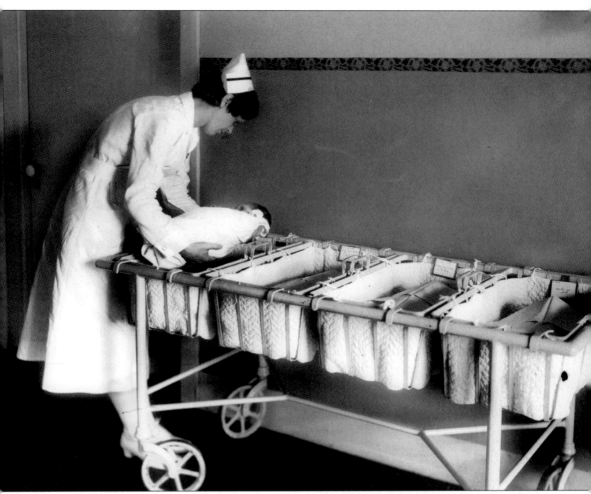

Warren General Hospital literature reported in 1935 that 329 babies had been born there the previous year. In this view, an obstetrics nurse places a newborn in one of the hospital's 22 bassinets. The hospital's maternity department boasted "not a mother lost in more than a thousand births" and credited the statement to skillful nursing coupled with modern equipment.

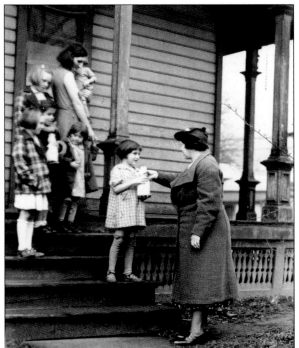

Volunteers rallied to aid their fellow citizens following a flood in 1882, and the Warren Relief Association was born. Incorporated in 1900, the organization provided assistance to families in need in a variety of ways, including providing milk, food, clothing, and shoes. In this 1930s photograph, Warren Relief's office manager, a Mrs. Cobb, hands a bottle of milk to a young girl as her mother and siblings look on.

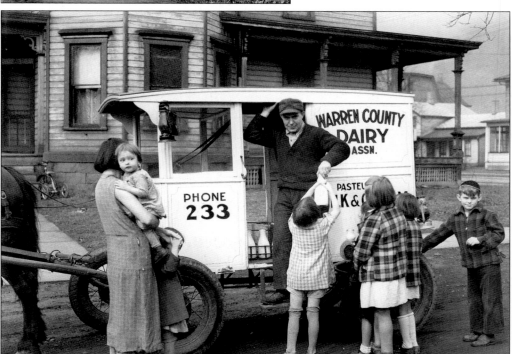

The Warren County Dairy Association milk wagon delivers milk to a family in 1938. Providing milk to children in need was one of the Warren Relief Association's most important community service efforts.

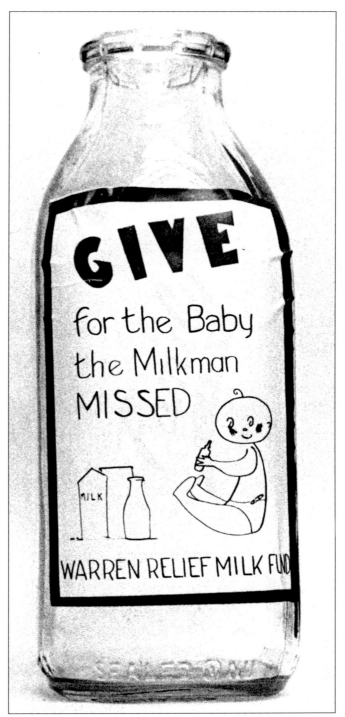

The Warren Relief Association's programs involved placing milk bottles throughout town with a label that read, "Give for the baby the milkman missed." The program began in the 1930s and was met with great success.

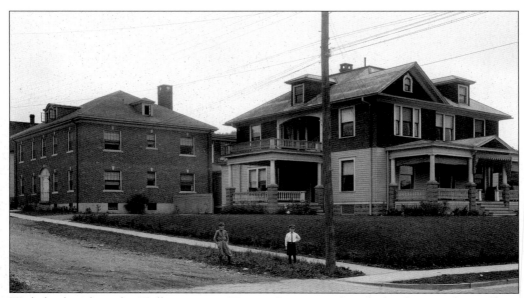

With funding from the Hoffman estate, Warren County purchased what became the Hoffman Children's Home in 1931 from the Children's Aid Society. Nancy L. Hoffman left her stepson, Otis F. Hoffman, as trustee of her will when she died in 1894. When he died in 1921, his will stipulated that Nancy L. Hoffman's entire former estate be given to Warren County (after the death of his wife) "to establish and maintain a home for the poor and homeless children of Warren County." The home, at 444 Conewango Avenue, was donated by Mrs. Harley Davis to the Children's Aid Society.

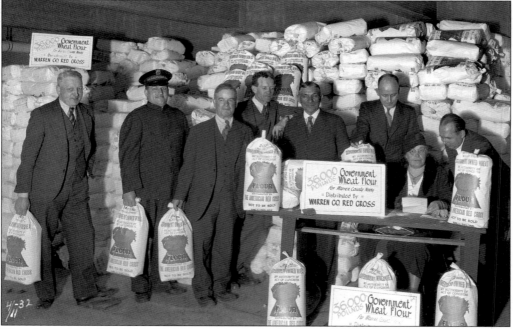

This photograph shows preparations for Red Cross flour-ration distribution in Warren on April 11, 1932, at the height of the Great Depression.

Kiwanis Club members organize the efforts of their clothing drive on May 1, 1945. The Kiwanis Club of Warren has been one of Warren's most active civic groups since its organization on July 12, 1922.

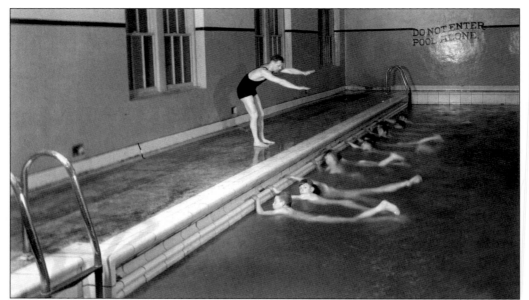

These children are at a swim lesson at the YMCA. The YMCA officially became a part of Warren's community on August 10, 1891, with Francis Henry serving as the group's first president. One of the organization's commitments is swimming education. Women and girls were first allowed to use the pool in 1920.

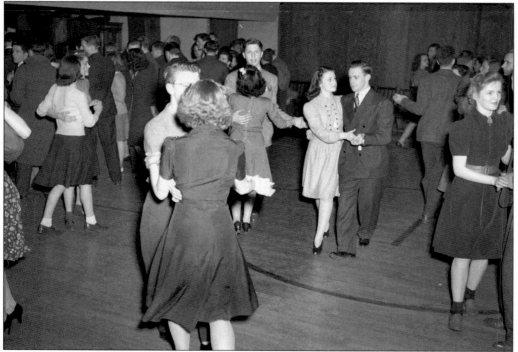

Among the myriad of activities for children and teenagers sponsored by the Warren YMCA were dances. A group of teens enjoys a dance at the YMCA at its former location at 310 Liberty Street, where it operated from 1915 until the building was razed in 1986.

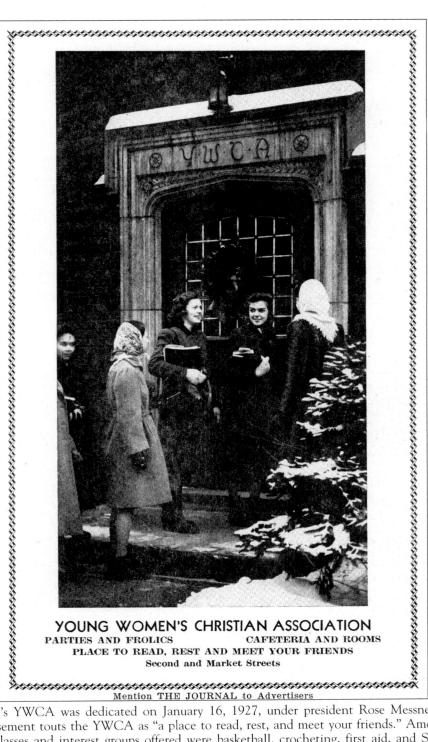

Warren's YWCA was dedicated on January 16, 1927, under president Rose Messner. This advertisement touts the YWCA as "a place to read, rest, and meet your friends." Among the many classes and interest groups offered were basketball, crocheting, first aid, and Spanish-language classes.

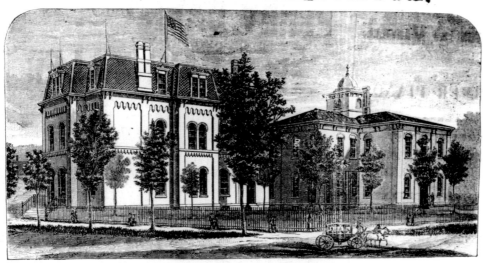

WARREN HIGH SCHOOL.

FALL TERM BEGINS SEPTEMBER 5, 1881.

The Warren High School Supplies the very

BEST ACADEMIC INSTRUCTION

LANGUAGE AND LITERATURE.

General History, Rhetoric, English Literature, Moral and Mental Philosophy, Constitution of the United States and Latin.

YOUNG TEACHERS

Can find no better place to learn the

BEST METHODS OF TEACHING

The high school was located at Third Avenue and Hickory Street until it moved to Second and Market Streets in 1897. Advertisements touting schools and their education programs were common because free education was nonexistent in Warren.

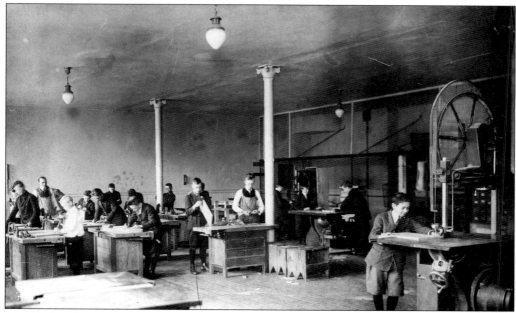

Mr. Broderick, standing in the left portion of this photograph, taught the manual-training class at Warren High School. Students in the class were required to make a piece of furniture.

Regular fire drills have long been a part of every school child's experience. This *c.* 1910 Warren High School drill shows students moving out to the building's fire escapes and down the steps to safety as teachers look on from the roof and the ground.

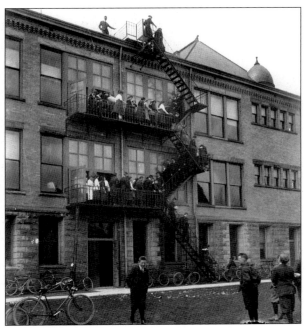

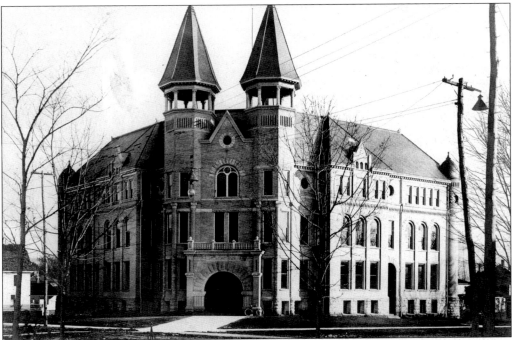

Warren High School stood at Market and Second Streets (on the site where the Ludlow House stood and the present-day site of Market Street School) from 1898 until 1961. Great thought and care were given to the building's appearance, and the December 31, 1898 edition of the *Warren Mail* reported, "The building is constructed of buff-colored pressed brick with Ohio sandstone trimmings and slate roof. The effect is pleasing to the eye and calls forth the admiration of all who see it."

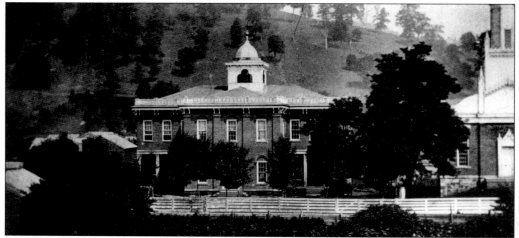

Warren's Union School stood east of the intersection of Third and Hickory Streets. Construction was completed and the school opened in December 1856. The Union School charged no tuition. *Warren Mail* editor Ephraim Cowan wrote, "It is a fine looking brick structure." Elementary and high school students were taught at Union School until the high school was constructed in 1898.

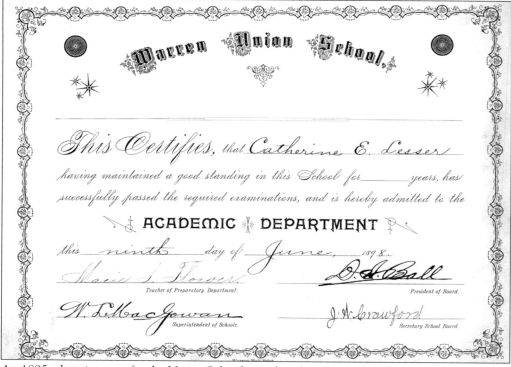

An 1895 advertisement for the Union School says that the school offered "thorough instruction in the common branches, Drawing, Vocal Music, Declamation, Composition and History." All students, rich and poor alike, received the same education and were held to the same academic standards. Certificates like this one announced that a student met the requirements for "academic courses."

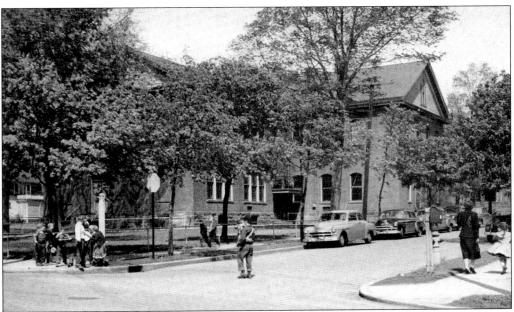

The first Jefferson Street School was demolished in 1952 and replaced with the new Jefferson Street School on the same site in 1953. The school was opened in 1877 as Glade Union School with just four rooms for pupils. An 1888 addition added several classrooms and an auditorium.

This is a copy of the "Order of Exercises" for Warren Academy for March 29, 1839, the date of the first commencement. Warren Academy opened in 1836 and closed in 1857. At the time it was built (1834–1836), Warren Academy and the courthouse were Warren's only brick structures. When the Union School opened in December 1856, charging no tuition, Warren Academy closed its doors, per the national trend of private tuition-based schools closing down in exchange for free, public schools all over the country.

WARREN ACADEMY.

ORDER OF EXERCISES.
Friday Evening, March 29th, 1839.

DISTRIBUTION OF SCHEMES.

MUSIC.

PRAYER.

MUSIC.

ORIGINAL ADDRESSES.

1 **Oration**—Rise and fall of Nations,	WILLIAM D. BROWN.
2 **Oration**—Straits of Thermopylæ,	JOHN C. BUCHANAN.
3 **Oration**—American Statesman,	JAMES E. KING.

MUSIC.

4 **Oration**—Dangers threatening our Government,	GEORGE N. PARMLEE,
5 **Oration**—Effects of Wars,	CHARLES KNAPP,
6 **Oration**—The force of a certain Monosyllable,	WILLIAM A. HACKNEY.

MUSIC.

7 **Oration**—National Glory,	JAMES BROWN,
8 **Oration**—Canadian Rebellion,	A. L. COOK.
9 **Oration**—Popular Prejudices,	ABRAM H. LACEY,

MUSIC.

10 **Colloquy**—	YOUNG LADIES.

MUSIC.

11 **Oration**—Death of General Warren,	LEWIS F. WATSON.
12 **Oration**—Chivalry,	JEROME B. CARVER.
13 **Oration**—Congress of '76,	RUFUS P. KING.

MUSIC.

14 **Colloquy**—	J., D., J. & J.

MUSIC.

15 **Eulogy**—Lord Byron,	JOHN N. MILES.
16 **Eulogy**—Thomas H. Benton,	LOTHROP T. PARMLEE.
17 **Eulogy**—Henry Clay,	LANSING D. WETMORE.

MUSIC.

18 **Address**—Valedictory	JEROME W. WETMORE.

MUSIC.

19 **Address**—Before the Hyadean Society,	George Smith, Esq.

MUSIC.

RASSELAS BROWN, PRINCIPAL.

N. W. GOODRICH, Printer, Warren, Pa.

93

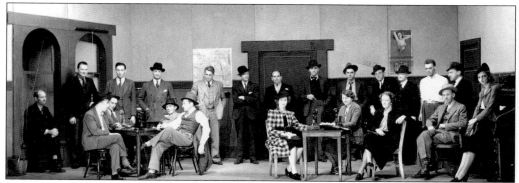

The Warren Players Club was created in 1930. The group's first production, *Her Husband's Wife*, was performed at the Woman's Club in February 1931. The cast of the October 1939 production of *Front Page* (above) was directed by S.M. McClure and Richard Smith.

The Warren Players Club, home of the Warren Community Theatre, purchased its building from St. Paul's Evangelical Lutheran Church. The congregation had the church built in 1904 and rededicated it in 1916 after a fire necessitated reconstruction. Warren Players purchased the building in 1971 when St. Paul's moved to a new location and began converting the interior to suit the group's needs.

Warren's First Baptist Church, located on Liberty Street above Third Street, was brought to Warren in 1859. Warren's Baptist congregation purchased the church building from a site in Kiantone, New York. At the time of the move (in the days before automobiles), it is anticipated that horses took on the task of moving the entire building—in pieces, of course. The First Baptist Church was razed in 1926.

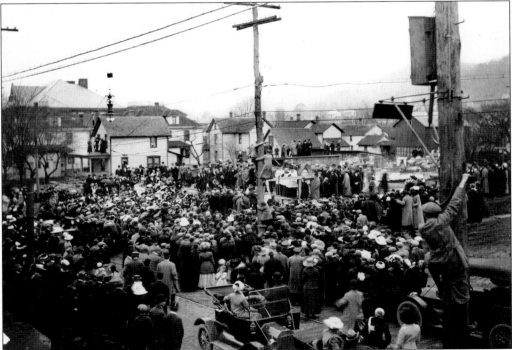

A large crowd gathered to watch the laying of the cornerstone of Holy Redeemer Catholic Church in 1910. People across the street (in the background of this photograph) stood on their porch overhangs to view the ceremony, and agile Warrenites climbed telephone poles so they would not miss anything.

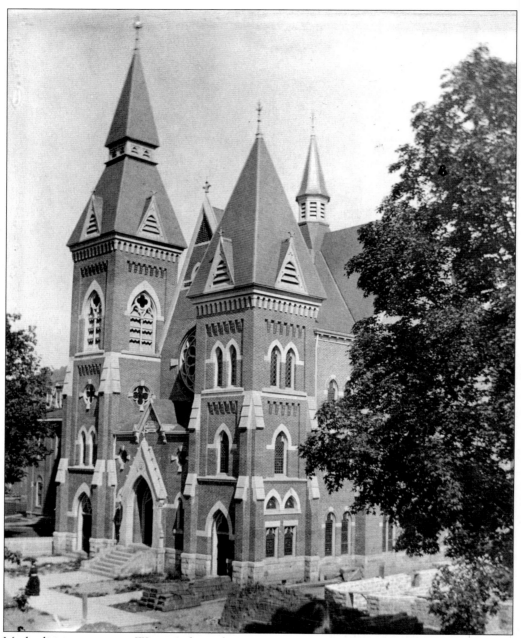

Methodists were among Warren's first religious congregations; the First Methodist Church was built in 1833 on Third Avenue, where it remained until the building shown here was built on the same site in 1885. In 1927, the congregation moved again and sold this building to the First Evangelical Church.

This interior photograph of First United Methodist Church, decorated for Easter, gives a glimpse of the building's gothic architectural style.

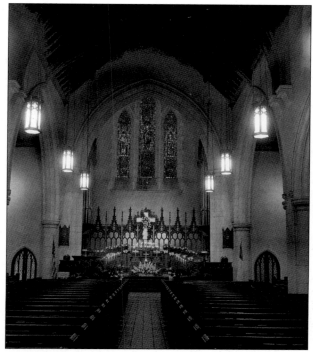

The Methodists moved in to this building at Market and Second Streets in 1927. The cornerstone was laid on September 27, 1925, by Jerry Crary and Dr. Charles Greer.

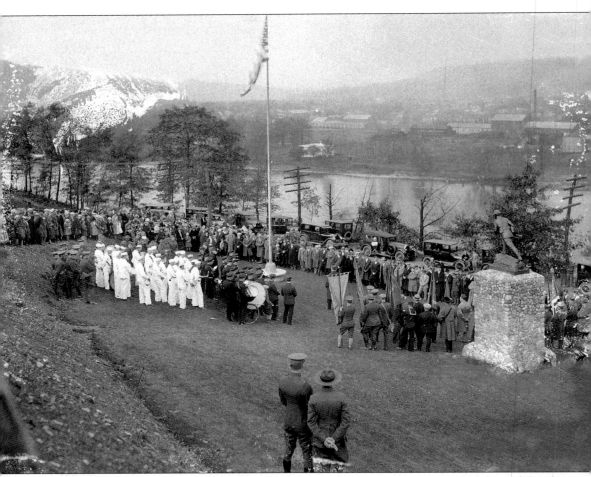

Oakland Cemetery was dedicated on October 12, 1863. An address was delivered by the Honorable S.P. Johnson, who said, "The well known public spirit and good taste of this community, give assurance that the beauties with which nature has adorned this now consecrated spot, will soon be out rivaled by art in the hands of liberality and refinement."

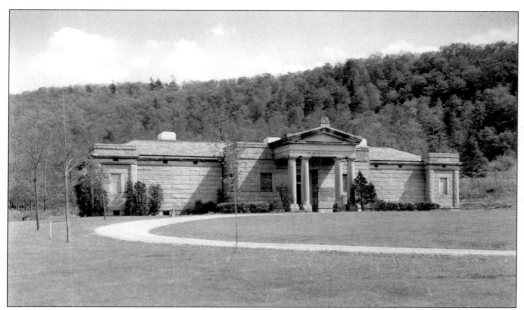

The Oakland Mausoleum was built in 1935.

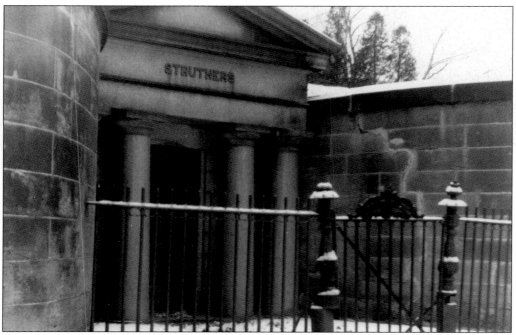

Thomas Struthers set forth in his will that the Struthers vault be not only "the depository of the remains of myself and wife and immediate descendants and especially my daughter, her husband and their joint descendants in direct line," but also a place to bury other blood relatives living in Warren County at the time of their death. The vault currently holds Struthers, Eunice Eddy, Thomas Eddy Struthers, Anna Struthers Wetmore, George R. Wetmore, Thomas Struthers Wetmore, Lottie Smith Galbraith, and Charlotte H. Smith. It has 18 vacant crypts.

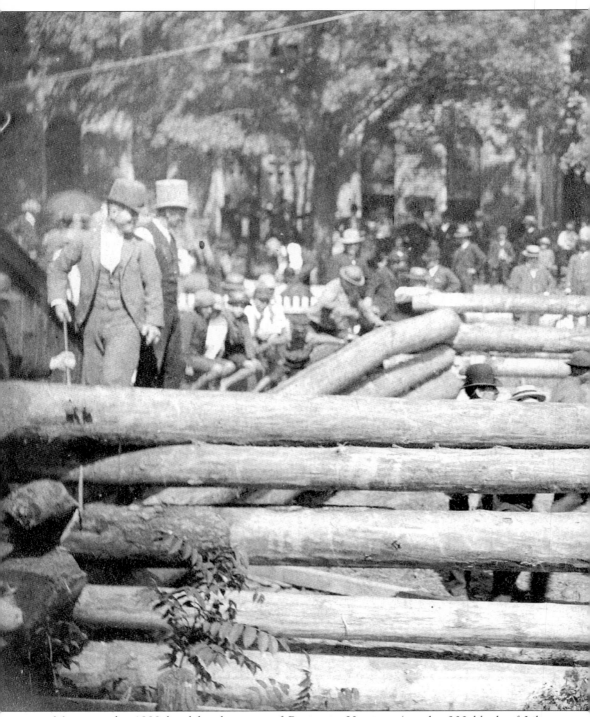

Men raze the 1888 local headquarters of Benjamin Harrison (on the 200 block of Liberty Street), the Republican presidential candidate who went on to become the 23rd president of the United States. After the election, the log-cabin headquarters was taken down by those who

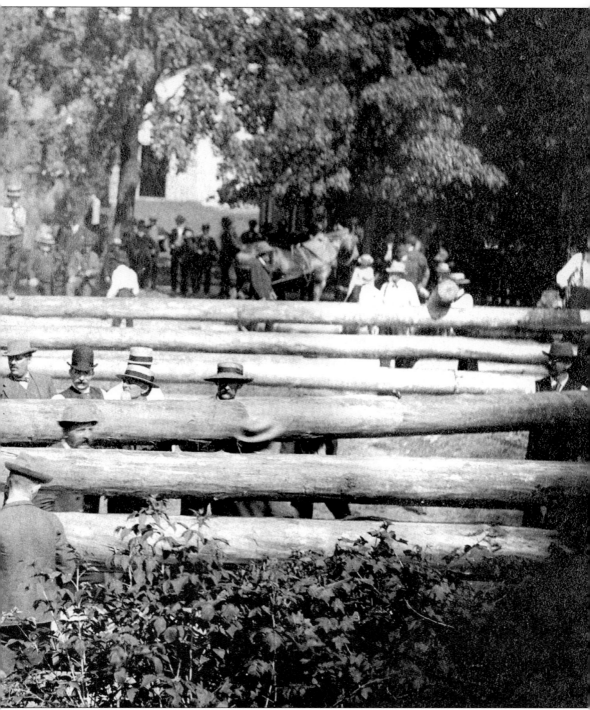

had built it and was transferred and then reassembled on the farm of Judge C.W. Stone, who used his farm as a summer home.

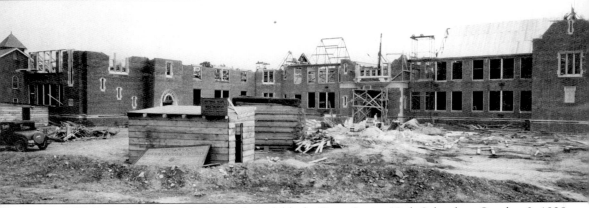

O.W. Beaty's estate made the land available for Beaty Junior High School on October 3, 1928. (O.W. Beaty was the son of David Beaty.) The school's construction, shown here in a photograph believed to have been taken in 1930, commenced and Beaty Junior High School opened in 1930 with Herbert Harris as principal.

Five

EVENTS

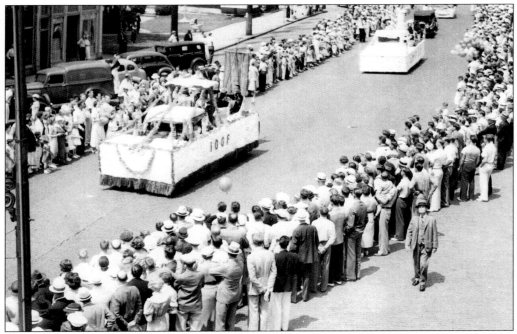

Annual and one-of-a-kind special events are celebrated in Warren—from parades and parties to anniversary celebrations and dedication ceremonies, and from holidays to life's everyday occasions. Included in this chapter are photographs from a firemen's parade, a pet parade, a Halloween parade, two different Fourth of July parades (including the 1936 parade, shown here), and a parade jointly celebrating Flag Day 1932 and Warren Borough's centennial, after which the *Warren Times Mirror* reported a renewed "pride in being a citizen of the community." Holidays such as the Fourth of July, Halloween, Thanksgiving, and Christmas are also marked with these festive marches.

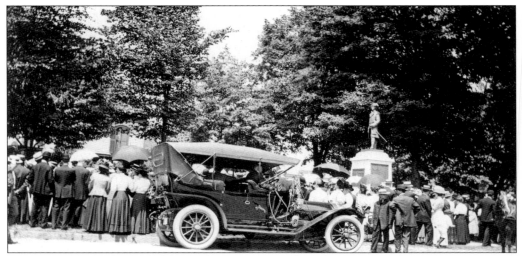

Warren citizens gather to celebrate the city's namesake. The Gen. Joseph Warren Monument was dedicated on July 4, 1910. Warren is named after General Warren, a Harvard graduate and hero of the American Revolution. After a program at the Library Theater, the crowd moved to the park where the monument is located.

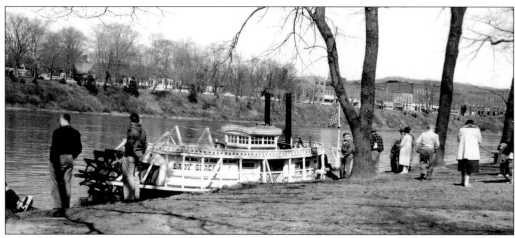

Lady Grace, shown here in front of the hospital, arrived in Warren on April 4, 1958, with owner Capt. Frederick Way Jr. It remained overnight before getting back on the water for the return trip to Pittsburgh. The ship's chimneys were lowered in order to clear the lower railroad bridge.

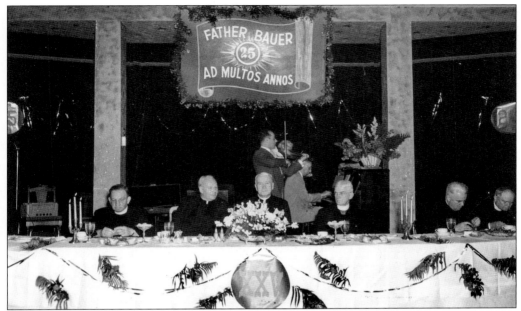

A dinner was held in honor of Fr. Alfred Bauer's 25th anniversary with the priesthood on June 22, 1949. The banner hanging above the head table reads, "*Ad Multos Annos*" (To Many Years). Bauer was an assistant at St. Joseph's parish in Warren following his June 22, 1924 ordination. He transferred in 1934 and returned to Warren as pastor of St. Joseph's in 1943, where he remained until his retirement as pastor in 1975. Reverend Monsignor Bauer died on March 27, 1980, in Warren.

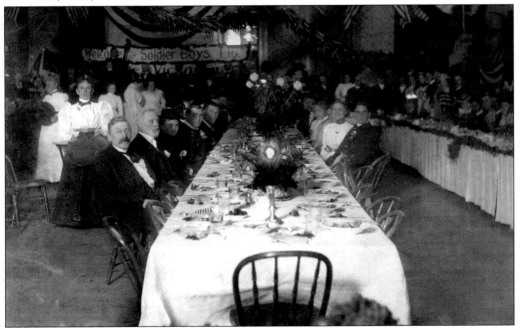

A banquet was held in honor of returned soldiers from Company I who fought in the Spanish-American War. The banquet was held on November 1, 1898, probably at the Warren Armory.

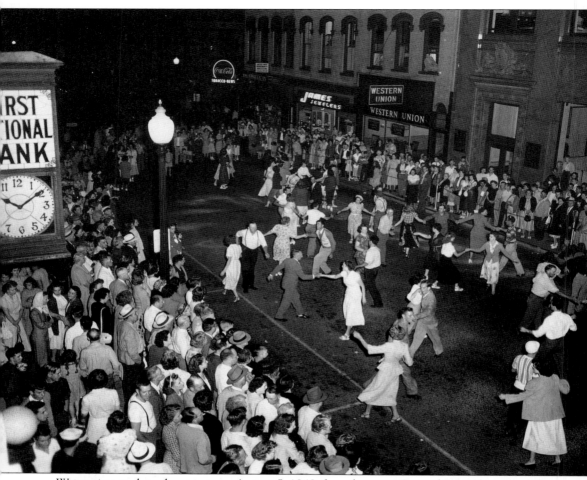

Warrenites took to the streets on August 5, 1949, for a dance on Second Street between Liberty Street and Pennsylvania Avenue. As the photograph illustrates, there was quite a turnout—close to 1,000 people, according to event organizers. Warren Chamber of Commerce's Retail Division sponsored the dance, Harry Summers Orchestra provided the music, and Bill Barr called the square dances. The Friday dance started at 9:15 p.m. (shortly after downtown merchants closed up shop for the night) and lasted until 12:15 a.m.

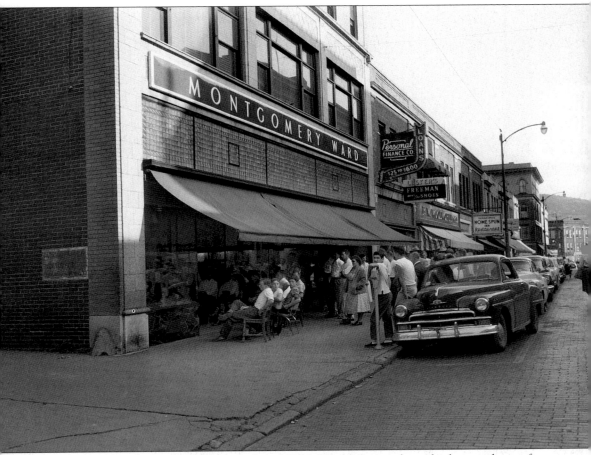

A crowd gathered to watch game one of the 1954 World Series through the windows of Montgomery Ward on September 29, 1954. The New York Giants swept the Cleveland Indians in four games, winning this game 5-2 in 10 innings.

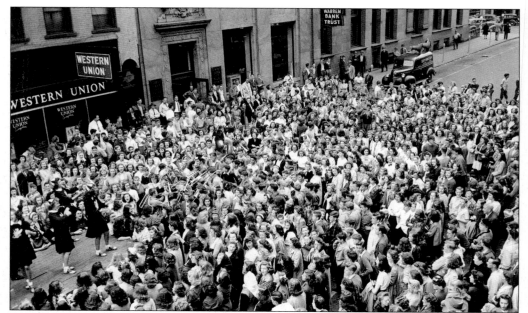

Hundreds of Warren High School students gathered on Second Street in an organized pep rally on October 11, 1946, in anticipation of a football game against rival Jamestown. Police blocked off a section of the street for the event. The band played, the cheerleaders cheered, and the crowd chanted, "Beat Jamestown."

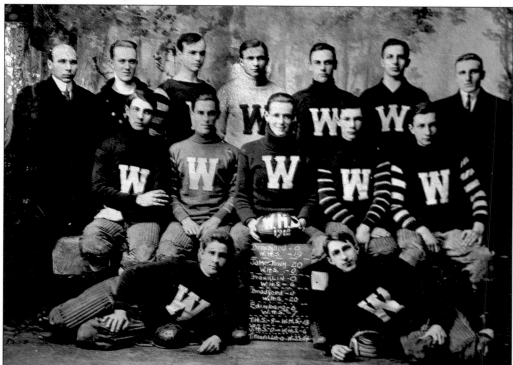

This Warren High School football team finished the season with a 7-1 record.

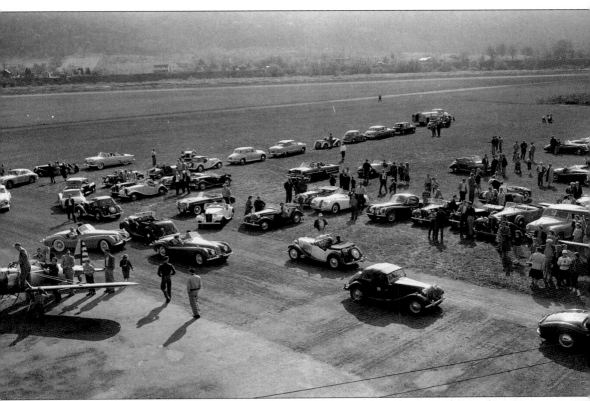

October 25, 1956, marked Warren's first sports-car rally, which was sponsored by the Warren Auto Sports Club. In this view, cars on the airfield prepare for the races to begin. Six cars from a club in Toronto were just a few of the 67 cars in attendance. The men's winner was Joe Bogalod of Pittsburgh; the women's was Mrs. Robert Anderson of Jamestown.

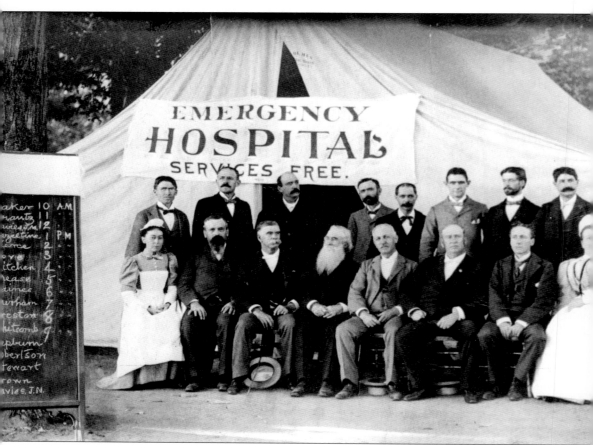

A street fair was held in 1897 to raise money for the new hospital. The sign on the left notes the times when certain personnel would be on hand. The doctors and nurses who participated are, from left to right, as follows: (front row) ? Bostwick (nurse), Dr. Love, Dr. Mease, Dr. J.M. Davies, Dr. Hepburn, Dr. Preston, Dr. Whitcomb, and ? Decker (nurse); (back row) Dr. Frantz, Dr. Robertson, Dr. Stewart, Dr. Brown, Dr. Kitchen, Dr. Durham, Dr. Haines, and Dr. J.N. Davies.

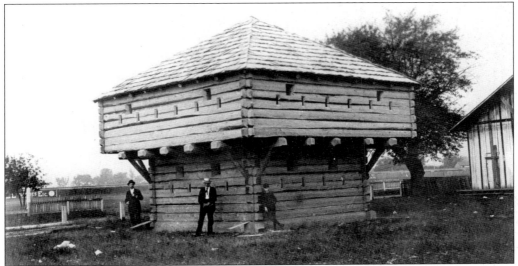

One of the highlights of Warren's centennial celebration (held July 2–4, 1895) was a reenactment of a battle between Warren's citizens and Native Americans, held at the blockhouse, built just for the centennial. At 4:00 p.m. on Tuesday (the first day of the celebration), the Native Americans demonstrated their attack method, and Company I "rescued" the blockhouse. Warren's centennial celebration was such a success that the number of attendees (from Warren and from out of town) was seriously underestimated. By noon on the third and final day, between 15,000 and 20,000 people were estimated to have been in attendance.

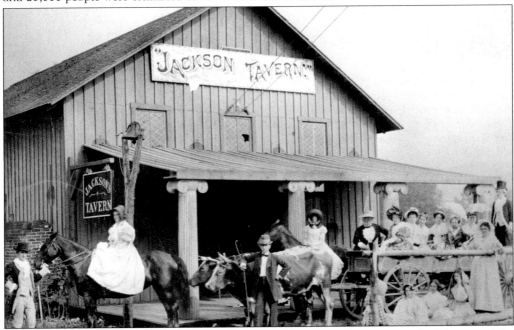

A replica of Jackson's Tavern was created as part of Warren's 1895 centennial celebration. The centennial's "Souvenir Synoptical Program" noted that buildings and the fairgrounds would be "fitted up for the booths and museums of relics, mementos, curiosities, war relics and other articles of virtue of historical value and interest."

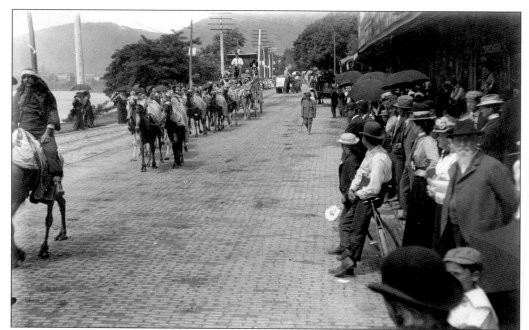

The book *One Night Stand* says that the circus was at its peak in the early 1900s. Warren was on the touring circuit, and each time a circus visited, it seemed to be better and bigger—with bigger animals, bigger and more daring acts and stunts, and bigger crowds. These photographs show a circus parade on Pennsylvania Avenue in the early 1900s.

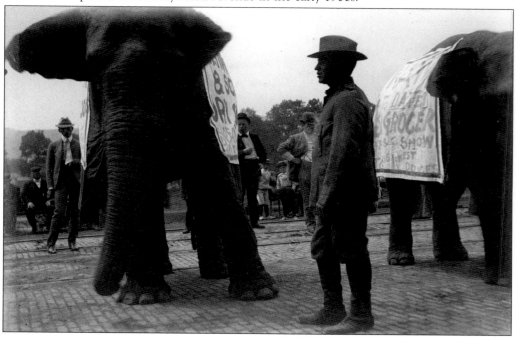

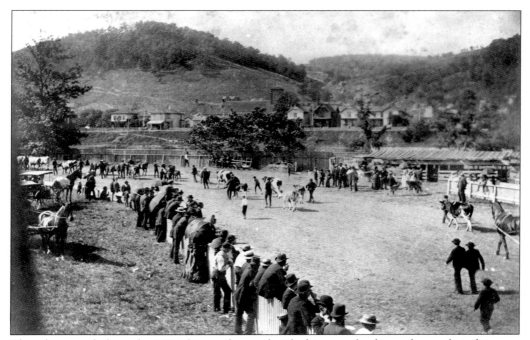

This photograph from the 1894 fair, at the south side fairgrounds, shows the cattle judging on the west end of the racetrack as the crowd watches. On the left are horse carriages that brought fairgoers to the fairgrounds.

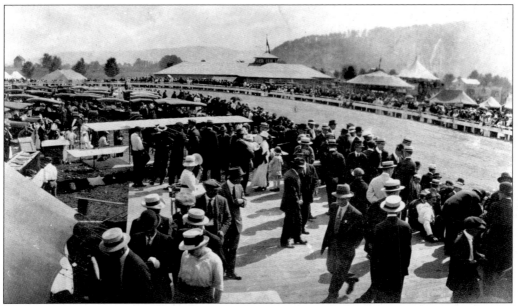

A crowd gathers at the old Warren County fairgrounds on Conewango Avenue (at Quaker Road) c. 1916. The foreground of the photograph shows the parking field, which was surrounded by a one-mile track used for horse-and-buggy racing.

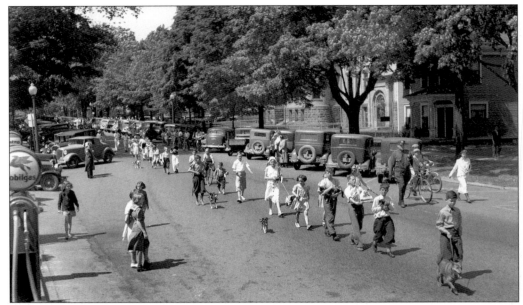

These are some of the entries in Warren's first pet parade. The event took place on June 6, 1936. Several hundred children took part, with pets including dogs, cats, fish, rabbits, turtles, horses, and snails. Judging took place at the end of the parade route at the Hickory Street bridge, where some of the awards that were handed out were for largest and smallest animal, most unique pet, and prettiest float.

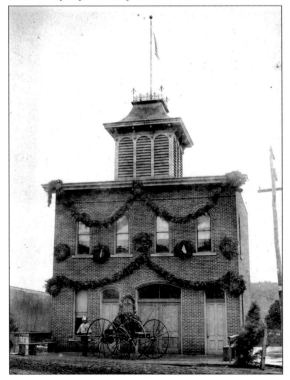

Parades for all occasions have always been popular in Warren. The Struthers Hose House & Carriage is decorated with garland for the second annual firemen's parade on August 25, 1885.

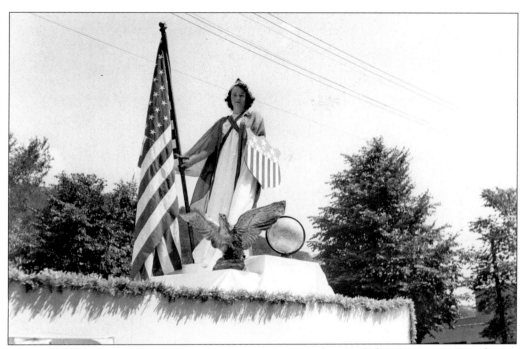

Frances Engstrom as Miss Columbia rides on the Daughters of the American Revolution (DAR) float for the 1940 Fourth of July parade. The local DAR was organized in 1910 and became an integral part of Warren's community.

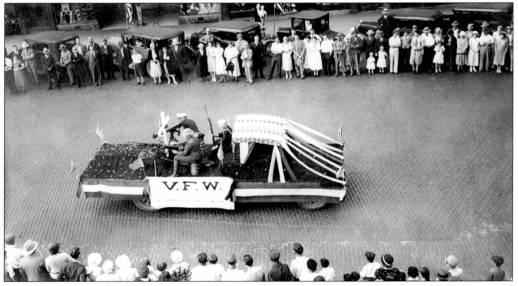

A parade down Pennsylvania Avenue was just one part of the joint celebration of Flag Day and Warren Borough's 100th anniversary on June 14, 1932. The parade included reminders of days past, such as an old steam-powered fire engine and an old Ludlow coach, coupled with contrasting reminders of advancement, such as motorized cars. An evening program at the Elks Club proved popular as well, with music, prayer, an address, and the singing of "The Star-Spangled Banner" to conclude the evening.

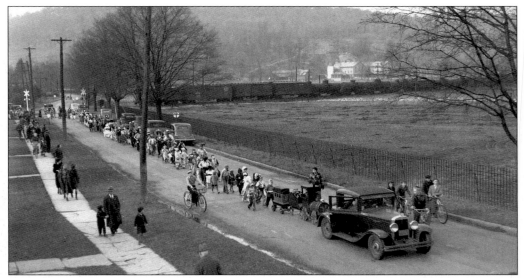

Halloween is always a time for costumes for Warren's children and adults. Children show off their costumes during this Halloween 1936 parade. That evening, the adults attended masquerade parties and costume balls around town, including those at the Revere Hotel and Muscaro's (which included a 15¢ fish fry).

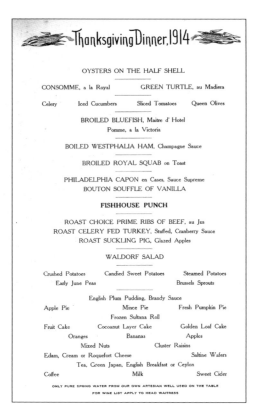

Thanksgiving Dinner, 1914

OYSTERS ON THE HALF SHELL

CONSOMME, a la Royal GREEN TURTLE, au Madiera

Celery Iced Cucumbers Sliced Tomatoes Queen Olives

BROILED BLUEFISH, Maitre d' Hotel
Pomme, a la Victoria

BOILED WESTPHALIA HAM, Champagne Sauce

BROILED ROYAL SQUAB on Toast

PHILADELPHIA CAPON en Cases, Sauce Supreme
BOUTON SOUFFLE OF VANILLA

FISHHOUSE PUNCH

ROAST CHOICE PRIME RIBS OF BEEF, au Jus
ROAST CELERY FED TURKEY, Stuffed, Cranberry Sauce
ROAST SUCKLING PIG, Glazed Apples

WALDORF SALAD

Crushed Potatoes Candied Sweet Potatoes Steamed Potatoes
Early June Peas Brussels Sprouts

English Plum Pudding, Brandy Sauce
Apple Pie Mince Pie Fresh Pumpkin Pie
Frozen Sultana Roll
Fruit Cake Cocoanut Layer Cake Golden Loaf Cake
Oranges Bananas Apples
Mixed Nuts Cluster Raisins
Edam, Cream or Roquefort Cheese Saltine Wafers
Tea, Green Japan, English Breakfast or Ceylon
Coffee Milk Sweet Cider

ONLY PURE SPRING WATER FROM OUR OWN ARTESIAN WELL USED ON THE TABLE
FOR WINE LIST APPLY TO HEAD WAITRESS

Patrons of the Carver House celebrating Thanksgiving in November 1914 were greeted with this menu, featuring traditional Thanksgiving favorites (stuffed turkey with cranberry sauce, candied sweet potatoes, waldorf salad, and fresh pumpkin pie) as well as dishes that have since fallen from popularity, such as fishhouse punch, green turtle, and roast suckling pig.

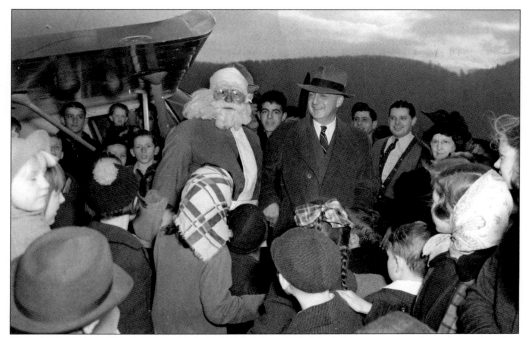

Santa's arrival is always a big deal to children and adults alike, no matter how he makes his arrival. Santa had arrived by plane when this photograph was taken at Warren Airport in the late 1940s.

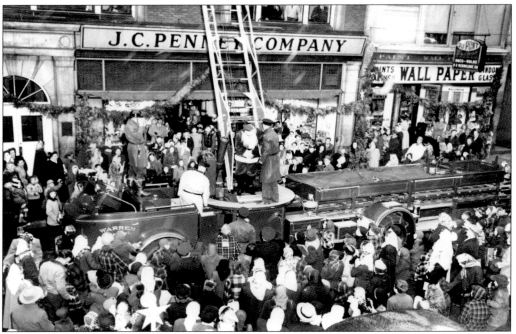

As this scene on Liberty Street illustrates, Warrenites bundled up and braved the cold to catch a glimpse of St. Nick. The Warren Fire Department happily lent a hand in the affair, letting Santa ride on one of its trucks and sounding the horn.

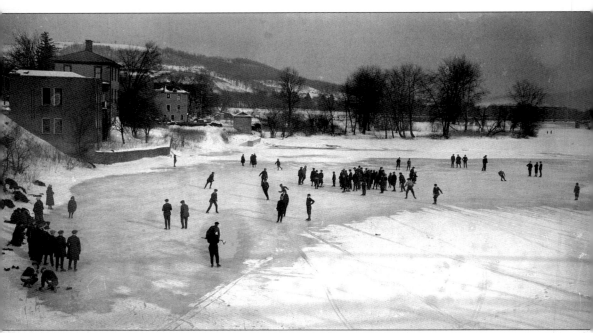

The upside to winter's chill is wintertime fun, which includes sled rides, snow days, and ice-skating on the Conewango.

Snow is part of everyday winter life in Warren. In this photograph of Market Street after a fresh snowfall in the 1920s, notice the difference between the tree-lined street of the early 20th century and the Market Street of today.

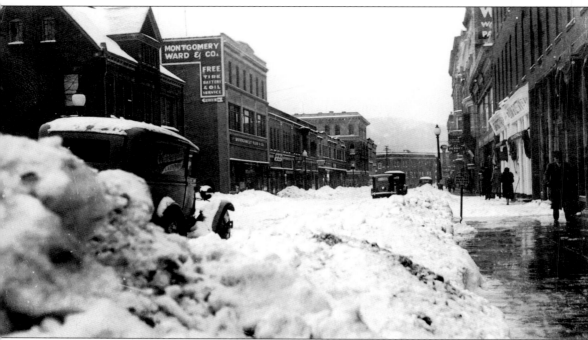

In anticipation of the St. Patrick's Day 1936 snowstorm, the results of which are shown here, the *Warren Times Mirror* ran a briefing regarding school closings: "If there is to be no school during the forenoon, there will be a long whistle blast from the plant of the Hammond Iron Works, Penn Furnace and Iron, Crescent Furniture Company and Conewango Refinery promptly at 7:45 o'clock." School remained open, although rain that followed the snow caused a flood.

Six

TRAGEDIES

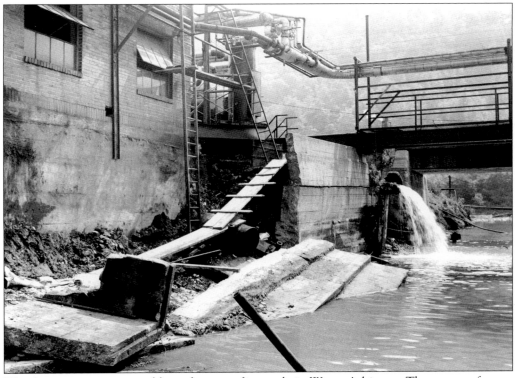

Wooden structures were to blame for many fires early in Warren's history. The nature of many of Warren's businesses (namely oil refining) magnified what might have been manageable fires into great disasters, as evidenced by a string of refinery fires, among them the United Refining Company and the Cornplanter Refining Company. Flooding, which occurred virtually annually in Warren until the Kinzua Dam was built, tended to be more of an annoyance than anything else, although some have caused more damage than others. Interesting photographs from the floods of 1909 and 1939 offer a glimpse into daily life during a flood, as does this photograph of flash-flood damage to the United Refining Company.

Workers assess the damage from a flash flood that struck the United Refining Company on August 1, 1956.

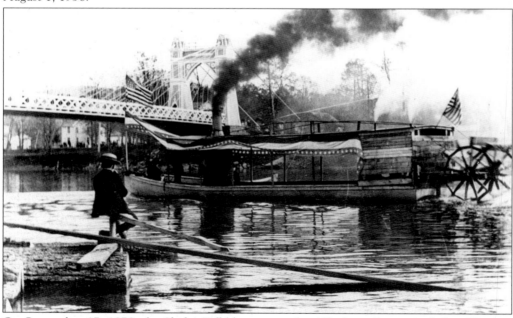

On September 17, 1878, the *Shirley Bell* blew up on the Allegheny River just below Warren. Hiram C. Shirley, the boat's owner and inventor of a reverse gear for a steam engine, died in the explosion. Warren's Struthers Wells Corporation used the gear as a model for its own equipment. This photograph shows a later version of an Allegheny steamer excursion boat that the *Shirley Bell* is said to have resembled.

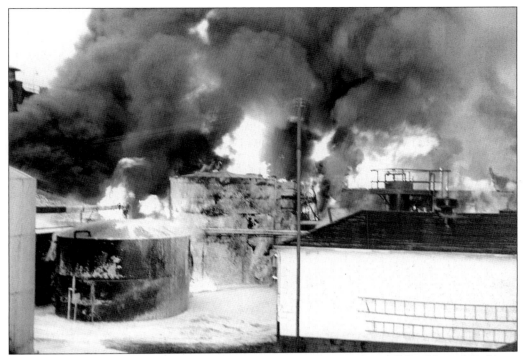

On October 30, 1955, an explosion occurred at the Seneca plant of the United Refining Company (about a mile from the main plant); the explosion is believed to have started in the chilling plant. The fire was brought under control within two hours, and all six employees on site were uninjured.

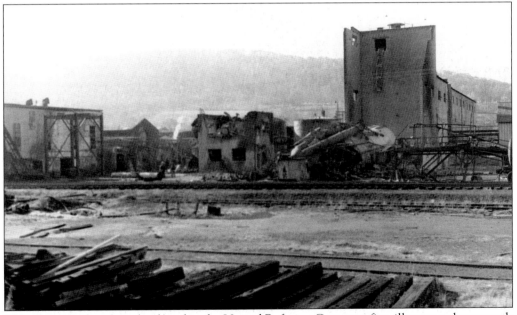

This photograph, taken the day after the United Refining Company fire, illustrates the upwards of $500,000 in damage. Rebuilding of the plant began immediately.

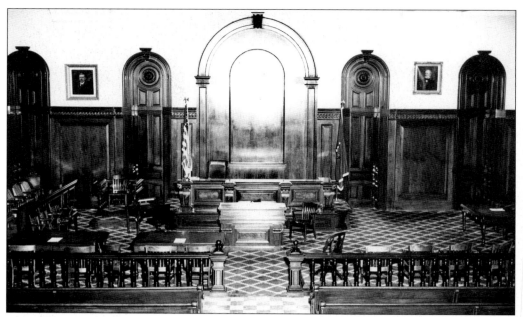

These photographs show the courtroom where Judge Allison D. Wade was presiding over a case on January 13, 1954, when Norman Moon entered the room and fatally shot him. Judge Wade had presided over Moon's divorce case with his wife, Nancy, in which Moon was ordered to pay $30 per week in support, a sum rumored to be unusually large because of Nancy Moon's parents' friendship with the judge.

Moon's gunshot left this bullet hole in the courtroom wall behind Judge Wade's bench.

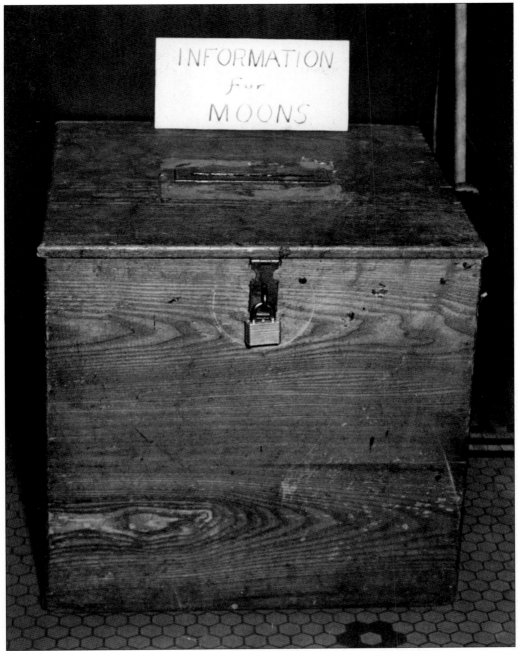

An old ballot box was placed at the Carver Hotel with a sign reading "Information for Moons" to collect information about the Moon case.

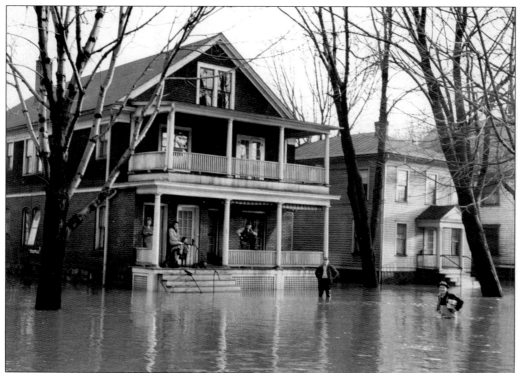

Flooding was an annual problem in Warren before the Kinzua Dam was built. Residents expected and prepared as best they could for a flood each spring because of the amount of snowfall received each winter. This photograph, taken on Water Street in 1937, shows a resident waist-deep in water as well as some onlookers from the dry safety of their front porch. Warren's schools had "water days" akin to today's "snow days."

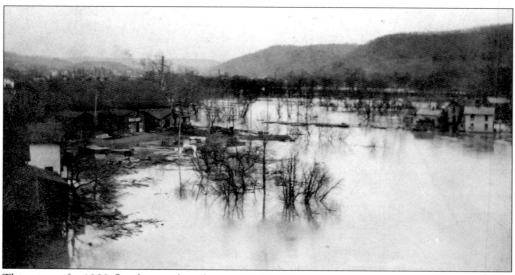

This view of a 1909 flood was taken from a Market Street vantage point.

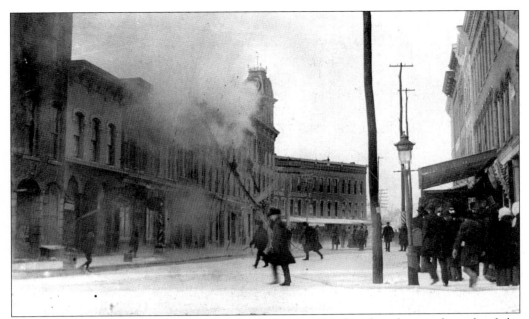

The Warren Savings Bank was lost in the February 1889 fire that destroyed much of the Watson-Davis block. The fire is in progress as firefighters try to get the flames under control. The flatiron building at the Point that housed the bank was rebuilt, as were many others on the block.

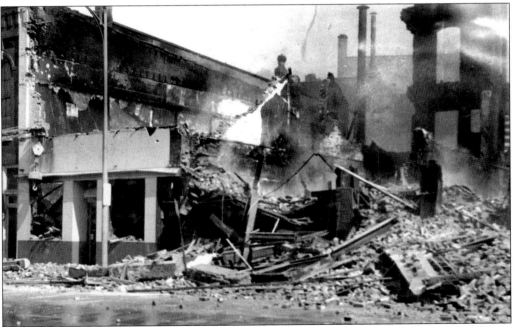

The Carver Hotel fire occurred on April 25, 1956. Central Station received word about the blaze at approximately 1:20 a.m. and battled through the night. With help from many nearby units, the fire was brought under control at approximately 5:00 a.m. The hotel itself and four guests' lives were lost, but many lives were saved, including those of the other 65 guests.

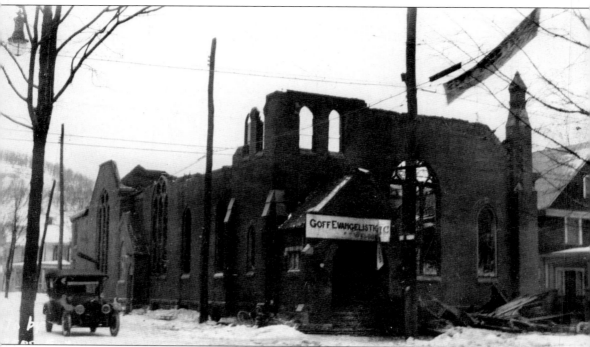

Grace Methodist Church was completely destroyed by fire on January 23, 1920. The church's $24,000 insurance policy was not enough to cover the estimated $75,000 in losses. The "Goff Evangelistic" sign in front of the church indicates that Grace Methodist took part in a program where churches had evangelical services come to their church for a week or two. Temporary signs were hung in front of the churches to indicate the minister's name (in this case, Goff).